OMAR KHOLEIF

With an afterword by
Lubaina Himid CBE RA

Magda Stawarska

Series Editor: Dr. Omar Kholeif
Commissioning Editors:
Caroline Schneider and Dr. Omar Kholeif

Editorial Advisory Committee:
Zoe Butt, Chiang Mai
Carla Chammas, New York and Beirut
Alison Hearst, Fort Worth, TX
Skye Arundhati Thomas, Goa
Sarah Perks, Tees Valley

Series: imagine/otherwise
Volume 1: Sonia Balassanian
Volume 2: Magda Stawarska

ISBN: 978-1915609298
ISBN casebound: 978-1915609656

Distributed by The MIT Press, Art Data,
Les presses du réel, and Idea Books

Cover:
F.D.N.Y Siamese Connection, 2019, photopolymer etching, silkscreen
print, and painting on Somerset paper, 58.3 × 85 cm

Inside cover:
July Issue 1976, 2019, silkscreen print, acrylic painting, and collage,
120 × 80 cm

An artPost21 Production **artPost21**

OMAR KHOLEIF

With an afterword by
Lubaina Himid CBE RA

Magda Stawarska

imagine otherwise

Sternberg Press

imagine/otherwise

imagine/otherwise is conceived as an emerging anthology of books on queer, nonbinary, and female-identifying artists who have produced a substantial body of work but do not have a publication about their art or life at the time of commissioning. The series—a living archive and modular score—comprises books that serve as field guides into artistic lives that remain unexplored or inaccessible. The overall proposition, to "imagine" a world "otherwise," stems from the desire to find a different way of looking, writing, and reading about art. To consciously create a form of publishing that allows art to be examined unreservedly, unburdened of the limits imposed by any perceived "dominant hand" of hegemony. Imagine if every book on art was authored or narrated via the distinct contours of the artist's work and/or biography—the writer and artist guiding the reader through a personal lens, in their distinct voice, rarely conforming to a singular style. Each book in the series is conceived as an exploratory document and collaborative composition. Together, author and artist, dead or alive, propose acts of world-building—fulfilling a dream to explode the sanctioned modes through which art is experienced in the collective imagination.

Magda Stawarska in Vienna, 2016. Photo: Deborah Stevenson

Contents

Translating the City: Sounds of the Sea, 2019 (detail). Installation view: "Invisible Narratives: New Conversations about Time and Place," Newlyn Art Gallery

Foreword

There are things we cannot reach, envisage, imagine alone.

When I began discussing the prospect of a new book series with Omar Kholeif, they proposed a living library of volumes on queer, nonbinary, and women artists. As with much of their prolific curatorial work and writing, Kholeif was eager to convene a communal process around this idea—a collective to help think through the inner worlds of artists whose practices have largely been looked at from the margins. Indeed, the ways in which art is inextricably linked to the worlds these figures occupy is paramount to how imagine/otherwise, a series of critical biographies on overlooked artistic figures is fashioned.

The inaugural editorial advisory board—Zoe Butt, Carla Chammas, Alison Hearst, Skye Arundhati Thomas, and Sarah Perks—sketched a set of parameters for this evolving archive. They began by examining standardized style guidelines, searching for what these instructions elide, and what should or could be included—for instance, the capitalization of east and west to create a binary opposition was immediately interrogated.

In our initial conversations, Zoe Butt argued for approaching the series through the lens of "female worlding"—a process that privileges female agency and contemporary modes of feminist thinking and experience in a global context. The specificity of this perspective

informs the shape of each volume—from the choice of subjects and authors to the writing styles nurtured.

Following our first volume, on the Iranian-Armenian American artist Sonia Balassanian, Kholeif now looks at the art and life of Magda Stawarska—a Polish-born artist based in the United Kingdom who has heralded a practice she terms "inner listening." For the third volume, Skye Arundhati Thomas explores the relationship of psychoanalysis and portraiture in the interior life of the late Indian artist Lalitha Lajmi. For the fourth volume, Hans Ulrich Obrist travels with the Syrian-born artist Simone Fattal across influences that span philosophy, literature, and acts of mythmaking. This book includes an essay by Rasha Salti.

As with every venture, the experimental impulse fosters unexpected connections. The dialogue around imagine/otherwise has resulted in *Helen Khal: Gallery One and Beirut in the 1960s* (2023), about a trailblazer of the early Beirut contemporary art scene, which features rarely seen archival material that encourages a rethinking of modernity as defined by the western world. The very concept of what we perceive, what we know, and what we seek to envision is at the heart of this quest to imagine a world otherwise.

Caroline Schneider Omar Kholeif
Publisher, Sternberg Press Series Editor

Lina Poletti Strada I, 2023, painting and silkscreen print on Somerset paper, 152 × 102 cm

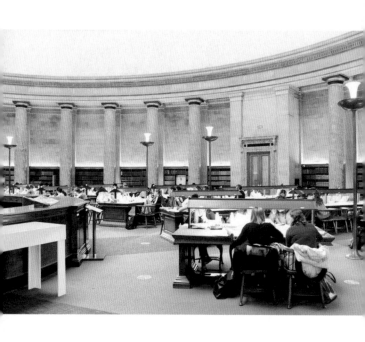

Manchester Central Library, 2018. Photo: Magda Stawarska

The Final Act
Brockholes

It is not uncommon for the narrator to begin at the story's end. On a blustering November morning, I am with Magda Stawarska in Brockholes, a small village in the northwest of England. The town's name derives from the eleventh-century settlement Brocole, which likely meant "badger hole."[1] An apt metaphor, considering that I have taken on the role of encouraging badger during the countless journeys I've embarked on with the artist. My presence has involved attempts to burrow into Stawarska's life and work—laying out the pieces of her practice for exposition—and her ensuing, often playful rebellion that manifests as self-analytic decoding or encoding. Over the years, the threads of architecture and music, language and sound, printmaking and painting have convened to constitute a life, an imagination, an artist whose way of experiencing the world has altered my own, and holds the possibility to do the same for others.[2]

As this is our last in-person encounter before I sit down to write this manuscript, I jokingly declare that I will use today's journey to perform my best Louis Theroux, referencing the documentarian and journalist. "The Louis Theroux in the interview with Joan Collins," I continue. Stawarska smiles. "I bumped into Joan Collins in a bathroom once at an award show," she says. "They had turned the loo into a dressing room for her."

"And did you speak to her?"

"I was interrupted by the woman who plays the Queen in *The Crown*, and I thought, Gosh, I have to get out of here."

"You weren't curious to engage any further?"

"I prefer to be a fly on the wall."

A term associated with realist documentary cinema, this statement could also serve as a thread throughout Stawarska's art. As a teenager, her way of seeing was inflected by the long takes of the Polish film movement known as the "cinema of moral anxiety,"[3] whose most influential member is Krzysztof Kieślowski. Stawarska told me his film *The Double Life of Véronique* (1991) is one of the works of art she treasures the most.

Kieślowski's durational, all-encompassing vision seems to have inspired Stawarska's flight in one of her most ambitious installations to date, *Music and Silence* (2023). First presented at HOME, Manchester, in fall 2023, this four-channel, 360-degree film projection places the viewer amid hushed scenes from the Manchester Central Library and the women's quarters of the Karol Poznański Palace, now the Academy of Music in Lodz.[4] Set up in a spacious round room, the installation shows two women—a Scottish performance artist and a Polish cellist. They are seen engaged in the rapturous, intimate act of listening.

The Polish palace was originally built in 1904 as a home for the Jewish chemist Karol Poznański, son of the industrialist Izrael Kalmanowicz Poznański. Its exterior is seemingly modest in comparison to his father's own palace—a transformed tenement building completed in 1877, now one of the city's major tourist attractions.

Karol's home was designed by the noted architect Adolf Zeligson, who also planned Lodz's Jewish Cemetery. During the Second World War, the palace's inhabitants were excised, and the building was used as a German music academy. In 1945, after the war, it became a Polish music conservatory.

Despite its simple exterior, the interior of Karol's former residence is detailed, luxurious, and grand; the setting animates the sweeping perspectives of Stawarska's cinematic gaze. The home abounds with the pragmatic necessities required for a domestic space as well as the flamboyant accents of marble fireplaces and stucco ceilings in a neoclassical style.[5] The cellist, twenty-year-old Alexandra Rosol, plays a chamber piece for cello and piano titled *Pohâdka* (*Fairy Tale*), a 1910 work by the Czech composer Leoš Janáček. The piano is nowhere in sight or earshot—its absence a metaphor for another absence that we do not know. Rosol instead keeps time based on the resonance of her own playing in the vaulted room.

Janáček's composition, adapted from Vasily Zhukovsky's epic poem *The Tale of Tsar Berendyey* (1832), was created during a period of mourning, following the death of the composer's twenty-one-year-old daughter Olga, who had fallen ill the previous year while studying in St. Petersburg. *Pohâdka* followed a composition dedicated to Olga titled *Jenůfa*. The latter was an opera that sought to evoke the pain his daughter experienced from the onset of her illness until her death in February 1903, just before construction began on the home. At that time, Zeligson would have been designing the layout and ornaments for the residence.

In Stawarska's sweeping camera shots, which include a bird's-eye view of Rosol's performance, she is situated in the private women's quarters, sanctioned neither for performances nor public access. Is this recital an act of restitution for the dead? The cellist can be conceived as summoning the ghosts of multiple pasts, or rather as an apparition herself. She embodies the longing and lament over Olga's death that is expressed in Janáček's piece, the despondency induced by the ethnic cleansing of the Polish Jews under Nazi occupation, or, as Stawarska articulates, "the invisibility of women classical musicians," who historically have been concealed behind a male conductor or composer. The absence of women filmmakers generally, and their cinematic gaze, is not lost on this viewer.

The tenderness felt by Stawarska, and the spectator, toward her subject deepens as the camera closes its orbit, the cinematographic equivalent of a pirouette. Rosol is revealed to be playing cello without shoes, in her socks, intimate but also childlike.[6] Here a bridge is formed with the voice of the Scottish performance artist Heather Ross, who can be seen reading in the round of the Manchester Central Library. Her voice is heard, but her lips do not move. Mental images form through her tranquil evocation of "gradients of silence," as we bear witness to her interior thoughts, which are given voice. She is enraptured in the "repetitive rumble" of the library's echoing rotunda, a vaulted site that bears architectural resonance with the palatial setting inhabited by Rosol. Her evocations begin to take the shape of a poem, of a humorous conversation that is she

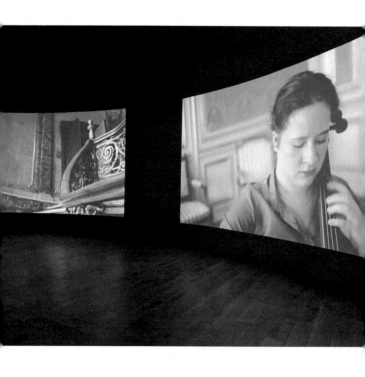

Above and following pages:
Music and Silence, 2023, 4-channel video installation, 4k and HD video with quadrophonic sound, 13:31 min. Installation view: "A Fine Toothed Comb," HOME, Manchester. Photo: Michael Pollard

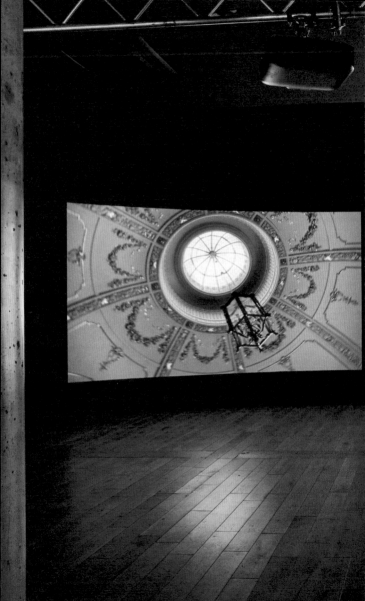

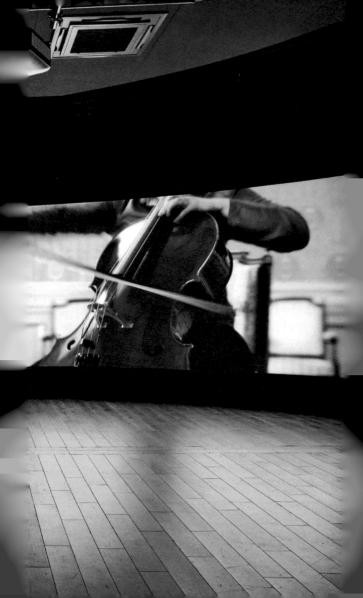

holding with herself.[7] The exhibition's curator, artist Lubaina Himid, notes, "We find ourselves witnessing two women, from very different contexts, listening to each other… and themselves. They are keeping time, in spaces that are seemingly private, which they have made incredibly private."[8]

Much like the journeys in *Music and Silence*, which developed over several years, so too the present volume, which was developed both formally and informally over three years of traveling, logging the experience of journeying with Stawarska. As a nonbinary traveler, neither flaneur nor flaneuse, I am seeking to reclaim the ground trodden upon by individuals who have historically had the privilege of movement, one that was not afforded to this author until naturalization as a British citizen in 2012. Here, with hope as my talisman, I attempt to unpick theories in reverse, as if weaving from a flashback of Stawarska's art and life. The reader will experience the artist's tender proximities, familiar dissonance, painted memories, and occidental dreams—a convening of abundance, of found kinship in the bruised wound—the castoffs of love. In the peculiar and fragile, in the fragment not the cleft, you and I shall halt to listen, first to ourselves, before we allow the rest of the world in. The end, like our beginning, involves an act of walking. That journey, like many throughout, are repeated, but to invoke Stawarska's lived practice, she never walks the same route the same way twice.

Above:
Music and Silence, 2023, video still

Following pages:
Film set of *Music and Silence*, Karol Poznański Palace Music Academy, Lodz, July 2023.
Photo: Oliver Stawarski-Beavan

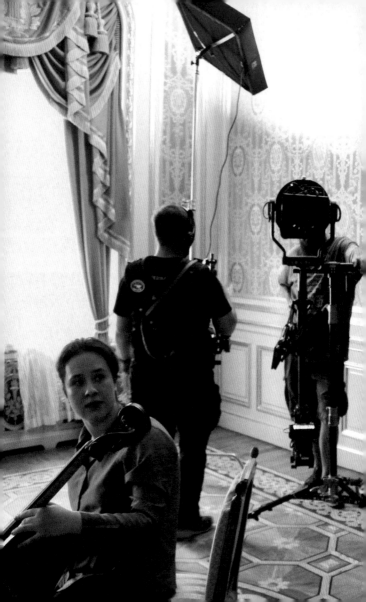

Opposite:
Film set of *Music and Silence*, Karol Poznański Palace Music Academy, Lodz, July 2023.
Photo: Oliver Stawarski-Beavan

NOTES

1. Alan Wright, "Brockholes, Brockhall: What's the Difference?," June 25, 2018, Wildlife Trust for Lancashire, Manchester & North Merseyside, https://www.lancswt.org.uk/blog /alan-wright/brockholes-brockhall -whats-difference.

2 See Emily Bick, "Elemental Thinking," *Wire*, March 2022; and Lubaina Himid, quoted in Rachel Spence, "Painter Lubaina Himid on Inequality in the Art World," *Financial Times*, October 21, 2023.

3. Also called the "cinema of moral unrest"or the "cinema of moral dissent," this movement included filmmakers such as Krzysztof Kieślowski, Janusz Kijowski, Andrzej Wajda, and Agnieszka Holland. The term was coined in 1956 by the Polish author and screenwriter Marek Hłasko. The movement revealed the crises of the country's communist regime through a naturalistic filmmaking style. It waned in the 1970s because of new restrictive legislation. See Marek Haltof, *Polish Cinema: A History*, 2nd ed. (New York: Berghahn, 2018), 145–48.

4. The installation was part of the exhibition "A Fine Toothed Comb," curated by Lubaina Himid, HOME, Manchester, October 7, 2023–January 7, 2024.

5. Leszek Skrzydło, *Rody fabrykanckie* [Factory families] (Lodz: Oficyna Bibliofilów, 1999), 60.

6. When I asked about the performer's clothing, Stawarska noted," The clothes that she is wearing were carefully chosen, the shirt is actually mine, I wanted her to feel comfortable. [...] When she took off her shoes during the rehearsal, it felt right to me." Stawarska, interview with the author, Preston, December 5, 2023.

7. Magda Stawarska and James G. Mansell, "Between Noise and Silence: Listening to the Modern City," in *Practicing Place: Creative and Critical Reflections on Place*, ed. E. Speight (Sunderland: Arts Editions North, 2019), 104–5.

8. Lubaina Himid, conversation with the author, exhibition opening, Manchester, October 2023.

Above:
Kraków to Venice in 12 Hours, 12-hour outdoor sound installation.
Installation view: Brno International Music-Exposition of New Music, 2015

p.29: *Kraków to Venice in 12 Hours: Clock*, 2013, digital print
p.33: *Kraków to Venice in 12 Hours*, 2013–ongoing, interactive webpage
p.34: *50.06465,19.94498 to 45.441058,12.320845* from *Krakow to Venice in 12 Hours*, 2013, set of 6 silkscreen prints, 110 × 76 cm each

The First Route
From Liverpool to Preston
and Back Again

It is late morning in the autumn of 2009, and I am standing on the balcony of the staff offices at the Foundation for Art and Creative Technology (FACT) in Liverpool. The view stretches over clusters of newly converted industrial buildings to the Mersey River, the sight of water a salve during this solitary period. Sunlight streaks across the round sky, creating ripples through the windows, an effect reminiscent of Nam June Paik's light works. It suffuses me with warmth, calming the anxieties of being in a place that feels like it will never be familiar.

Earlier in the year, I relocated from my adopted hometown of Glasgow to take on the challenge of a new job. The curatorial position at FACT had begun with an invitation to help shape its archive. One of my favorite artists at the time, Miranda July, had a residency at the center in 2003; it's rumored she had to end it early to make her first movie, *Me and You and Everyone We Know* (2005), a travelogue through the life of an artist. Flitting between whimsy and melancholy, the film captured what everyday life often felt like—a container of abstractions. I was eager to create something similar. I hoped that life and art would convene in this city.

A reckoning awaited. At FACT, everyone seemed to hurl their resume at you, if not to claim their worth then to make it known they'd be moving through the ranks before your next breath. Feigning bookishness became a shield; I kept quiet and listened.

Someone was waiting for me at my cubicle that chilly morning. I pulled my head in like a turtle and inched forward. A young woman reached her hand out to introduce herself. Her name was Aneta Krzemień, originally from Poland, and she was curating an exhibition at FACT while pursuing her doctorate at the Centre of Architecture and Visual Arts at the University of Liverpool. I was comforted by her foreignness; within her lilting Polish accent was something familiar. After fourteen years on and off in Scotland, England had presented me with a form of culture shock. In the north was a nationalism and references I did not have access to.

Krzemień lived in the city of Preston, about an hour's drive north of Liverpool. I knew of Preston for the Making Histories Visible archive, a collection of books and ephemera focused on Black creativity at the University of Central Lancashire (UCLan), assembled in 2005 by Lubaina Himid. Kinship among foreign bodies is an ongoing subject in the field of visual culture of both academic and literary study. The critical race and postcolonial theory I studied in graduate study in London, which I had begun the year prior, was contributing to a visual-arts revisionism elucidated in London group exhibitions such as "Veil," produced in 2003, and "Alien Nation" at the ICA in 2006. Both shows were co-organized by Iniva, an international institute focused on diasporic artistic practices, which provided a platform for artists including Jannane Al-Ani, Laylah Ali, Hamad Butt, Emily Jacir, Hew Locke, Harold Offeh, Zineb Sedira, Yinka Shonibare, and Eric Wesley.

Kraków to Venice in 12 hours

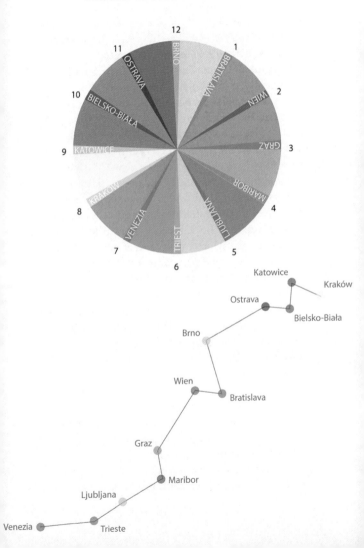

My graduate supervisor, the artist and writer Jean Fisher—formerly an editor of the postcolonial studies journal *Third Text*—held an interest in these artistic voices. Fisher and I were both drawn to their reclamation of the traveler as not merely a flaneur—traditionally, a (white) man who ambles along, discerning societal norms—but instead a figure who embodied the "trickster"or "coyote."[1] This conjuring of artistic presence offered a subversive guise that intervened in the historical record. Fisher's interests steered my gaze over the coming years. With her encouragement, I learned of the necessity to create space for myself both within and without the bounds of the institution. This became a form of quiet resistance.

Over coffee on Bold Street, Krzemień and I were discussing the various trajectories of her personal life. In articulating my loneliness, Krzemień brought up one of her lifelong friends from Poland who was now also living in Preston, the artist Magda Stawarska. At the time, Stawarska was developing *Arcade* (2010), a multimedia work made of sound recorded at Rynek Główny, the central public square in Kraków. It was going to be played in the Rotunda Café at the Harris Museum in Preston, which sits on a market square. The eight-hour score condenses an entire day of pace changes through sound—birdsong, footsteps, the hourly chiming of a clock, as well as an aural reference to a thirteenth-century trumpeter who was shot while trying to warn the city of an imminent attack.[2]

The layering of two temporal orders—a past that never ceases and the present, using the experience of

individuals (living, dead, or imagined) to animate a spatial and historical context, serves as an entry into Stawarska's endeavors to de-synchronize lived experience by evoking a state of melancholy—an intermittent feeling of despondency associated with lives and stories, often lost, which are briefly reanimated. The elegiac homage to the deceased trumpeter is poignant. Stawarska's practice seeks to both serve and sever the order of time—its linearity, tempo, politics—through an ongoing preoccupation with political borders. She attributes this interest to her upbringing in communist Poland, and the period of martial law, from 1981 to 1983, when it was nearly impossible to leave the country.[3]

With this context, it is no surprise that Stawarska's work involves studying, translating, and personifying the figure of the flaneuse—one who chooses to exist out of step with time. Reading Lauren Elkin's book, I was surprised to learn that Charles Baudelaire, was "disinclined"to give credence to the "women who walk the city."[4] The street in the popular imaginary was thus sanctioned exclusively for half of society—the men.

Stawarska's art, on the other hand, swells with the influence of significant women from art history and literature, many of whom purposefully walked the city, such as Sophie Calle, Rebecca Solnit, and Gertrude Stein. In her devoted process of consciously "getting lost"in various urban spaces she is simultaneously witness and interloper, negotiating both past and present. The artist's journeys are often discreetly captured with microphones that resemble headphones and a GoPro camera placed in different configurations. With these, she marches at a pace

set by circumstance—weather conditions, interests, and social norms.

In 2009, while plotting the coordinates for *Arcade*, Stawarska began developing an epic journey that would become *Kraków to Venice in 12 Hours* (2010–14). The impetus behind this epic excursion, which involved multiple border crossings within Europe, began with the artist's wish to cross the seemingly borderless Schengen Area from southern Poland to the Adriatic Sea. At the journey's end, Venice—a series of gradually sinking islands linked by bridges—unfolds in a modular installation of prints, soundscapes, drawings, and maps that reveals Stawarska interlacing of main streets and hidden paths. The image of the flaneuse is often left to the spectator to conjure, to route through their own lived knowledge and experience.

Both ends of Stawarska's journeys are UNESCO World Heritage sites, but in the popular imagination they are juxtaposed. Once a sovereign state, Venice is visited by about thirty million tourists annually, attracting three times as many visitors as Kraków. Except that the Venice archipelago is weeping. The periodic flooding of the city, *l'aqua alta*, fueled by climate change and overcrowding, presents an active situation of decay. Today, Venice exists as a phantasmic simulacrum, its identity held together by threads of nostalgia.[5] The heart of the installation—a twelve-hour audio recording—is steeped in pathos.

Stopping in Katowice, Bielsko-Biala, Ostrava, Brno, Bratislava, Vienna, Graz, Maribor, Ljubljana, and Trieste, Stawarska's journey is delineated by the sounds she encountered.

Magda Stawarska-Beavan

Map showing route with locations: Kraków, Katowice, Bielsko-Biała, Ostrava, Brno, Bratislava, Wien, Graz, Maribor, Ljubiana, Trieste, Venezia

● - Locations

● - Locations with Recording Samples

● - Completed Compositions

a sound project which mapes a
rney from Krakow, Poland to Venice,
aly, crossing the borders of 6
ntries: Poland, Czech Republic,
vakia, Austria, Slovenia, and
aly. The project is attempting to
pture the unique sonic identity of
places; searching for similarities,
nnections and divisions between the
tes travelled through. It acts as a
rsonal and subjective travel audio
ide and a clock for the journey,
pping the movement through
ographical locations and the passage
time, investigating how the
le/identity of the place changes,
ring course of the day.
e audio files are uploaded as the
urney progress and the work
velops. Beginning with the field

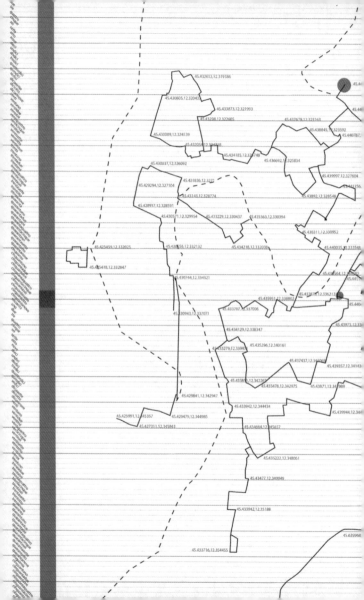

"I spent two or three days walking, recording, and finding locations in each city. The entire journey can take twelve hours. But the cities are not equally spaced, so the train journey between them varies. It took me four weeks of traveling to complete," Stawarska notes.

Church bells and clock towers find their rejoinder in the whispers of passersby. The voices of train platform announcers situate the listener geographically, while errant noises pop in and out of the composition. On the project's website, Stawarska discusses how the concept of "noise pollution" serves as a barometer of place or an identifier of difference.[6] For the artist, difference is not divisive but a means for an individual to specify how they perceive their identity in relation to a city. How one sound ricochets against another, unbuckling forms sonic interference, which for some might appear latent. Gusts of wind and echoes frame the sociopolitical context of each site. An interrogation ensues for the listener: How were these buildings constructed, devolved, and re-erected to breathe again in newfound ways?

In the various exhibited versions of the project, such as in the TONSPUR sound-installation series in MuseumsQuartier Wien in 2013, Stawarska negotiates the passage of time through spatial renderings. Intricate silkscreen prints of multiple maps hang both outside and inside the gallery. The coordinates of each recording location are rendered topographically on the prints. Stawarska's maps are not literal geographic representations but rather reveal the contours of urbanism captured through movement. In conjunction, the spaces of confinement and release discovered

reaching "dead ends" or finding "open passages" to continue walking propose an extra-territory that is entirely her own—one created by never walking the same route or, following the same path twice, even if the destination remains the same.

In each staging of *Kraków to Venice in 12 Hours*, a clock reveals the times at which different sounds were recorded. To my sensitive ears, the tolling of the bells evokes a picture of autocratic overlords—a tradition of sonic disturbance that elides the violence of such noise pollution. Lawrence Abu Hamdan's research project *AirPressure.info* and installation *Air Conditioning* (both 2022) present evidence that noise pollution, in all its forms, can harm the human body. The throbbing of aural interferences, his research reveals, makes people susceptible to chronic anxiety, accelerates the occurrence of heart disease, and induces paranoia.[7] Stawarska's body keeps the score of these auditory intrusions: she is most often recording with binaural microphones, which are intended to capture all of the audio frequencies that orbit the individual—embodied recording. In turn, Stawarska's acts of journeying are felt but not live in the same detail at the time of moving. The recording device may reveal another story, one that she often consults afterward.[8] Her body thus becomes the place where secrets are buried. What is constructed is the result of multiple acts of reconciliation with oneself, of stitching what was remembered and what is heard in each recording.

In the years since this installation was first exhibited, I have closely followed Stawarska's footsteps. Her lithe

body moves incisively, expediently, propelled by her athleticism honed by her running routine. I have seen Stawarska shirk the violence of individuals (often men) who verbally or physically seek to capture attention on the street. Her own body, she asserts, is a vessel for a form of "deep listening"—one inspired in part by the artist and composer Pauline Oliveros's theory and eponymous album from 1989.[9] For Stawarska, the term has as much to do with a profoundly introspective examination of the body's rhythms as it does with her geographic location. In all her work, when the artist stops, it is not merely to catch her breath, but to observe with both her microphone and camera. Yet it is the subjectivity of the experience itself—the camera that is swallowed by her person, cleaved to her body—that forms the artist's gaze, affecting the outcome of the work. When she stops to take in a scene, whether out in public or while editing, her eyes pan like a camera, similar to Agnès Varda's documentary *Les dites cariatides* (1986), which Stawarska cites as a source of inspiration.[10]

The sonic shifts and acts of temperate disobedience in her city journeys, I shall discover, find their own language in what the artist has coined "inner listening."[11] A process of space and time enmeshing with the affective quality of individual remembrance, inner listening is a cognitive act that emerges from a psychogeography, one marked through the body. A prime example is Stawarska's installation *Translating the City: Sounds of the Sea* (2018–19). Included in the group exhibition "Invisible Narratives" at the Newlyn Art Gallery in 2019, the centerpiece is a sound piece embedded in various

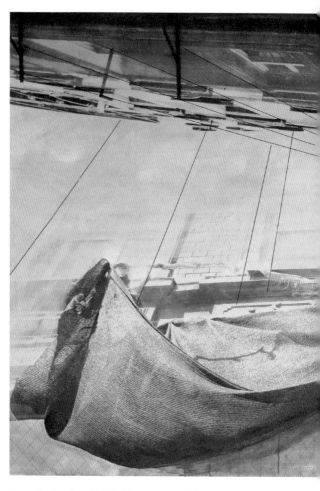

Bez na Ulicy Ireny Krzywickiej / Lilak on Irena Krzywiecka Street,
painting and silkscreen print, Somerset paper, 144 × 102 cm

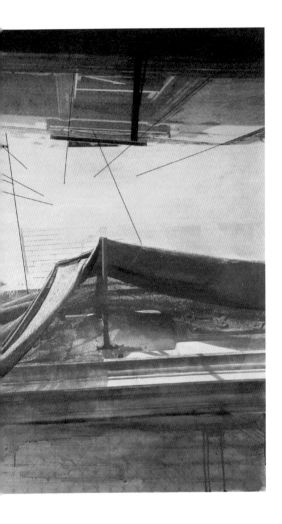

everyday objects on a worktable. The exhibition scene is almost theatrical, each object meticulously placed as if waiting to be woken by the visitor who is expected to physically engage with the artworks on display. A silkscreened map of Zanzibar from the early 1950s has been threaded into a notebook. It sits on the table, the adjoining page lit by a Piccolo projection of juxtaposing seascapes. The light—the apparatus that is the projector—remains concealed in a modernist-era desk lamp; sound plays from a Grundig radio from the 1970s. A voice is heard.

One's attention might be drawn to a different body of work, framed pictures that hang a distance away from the desk—*Curtain II: Burgtheater* (2016) or *Boulevard Anda* (2019)—which she developed through a hybrid process of photography and painting. The sensation is one of floating between or within the soft, flowing drapery covering windows, doors, and walls in the images. The fabric might serve as insulation, but it is also a neoclassical symbolism of mourning. A curtain sweeps across a wall, a burial plot, a tombstone, an emblem, a marker—covering it up, encasing its scars, the wounds, quickly.

The nation-states and other vestiges of ideology that Stawarska engages often conceal the traces of the route of time. Can the residues of violence found in the cityscapes she explored hide behind the curtains of artifice forever? For the wounds of conflict are sedimented into the architecture of the city, and Stawarska's art, I keep learning, allows for them to be both seen and heard. The installation at Newlyn Art Gallery brims with a sense of longing. I discuss Saidiya Hartman's evocation of a

search for an "elsewhere," or an "anywhere," in her own travelogue, *Lose Your Mother*.[12] In Hartman's case, she is seeking to make sense of what it means to be severed from family or kin, constructing a propositional context for the diasporic experience of Black Americans such as herself. Stawarska, too, it becomes evident, is searching for a route to connect with a sense of being in the world, as a woman, who has spent half of her life in conscious exile from her perceived home, searching.

In the gallery, we hear two voices. From within the folds of a precarious landscape they emerge, from two different orbits. They say:

Voice 1
> Men asking "men type"questions—
> Any excuse to invade space.
> Men asking "men type"questions.
> More chat-up lines.
> English music or Turkish music?

Voice 2
> Buy my stuff, buy my stuff!

Voice 1
> Zanzibar Street,
> An Arab Indian violin?
> Beeping, *beeping*—
> Blackpool!
> Fast tapping like morse code.

Both Voices
> Men!

Voice 1
> Endless waiting.

In the groove of waiting, a restlessness becomes apparent. What are we hearing? The sound recording was created as Stawarska traversed various crossings—back and forth under bridge and over land, across the Bosporus, in 2014. The strait of water that forms the boundary between Asia and Europe, the so-called east and west. Stawarska gave her sound composition to Ekin Sanaç, a musician and artist from Istanbul, and Lubaina Himid, who had never been to the city. Neither was informed of the specifics of the location or the conditions of the recording, and Stawarska encouraged them to reflect on the images the sounds conjured. The voices heard in the gallery are those of Sanaç and Himid, each describing what they see through listening. Stawarska edits the voices much like a call-and-response, as if one woman is echoing the interiority of the other, one assuaging the other's impatience.

The dyssynchronous nature of these recordings creates an aura of "interpersonal time." The prospect of constructing feelings with other listeners is a distinctive feature of inner listening. It is an embodiment of journeys unknown, which trigger memories of the familiar. In this installation, there is no small measure of melancholy. Melancholy results from desynchronization—the trigger of a memory, of nostalgia, of a longing to exist outside the confines of one's own mind or body for a certain period.[13] When pressed about these moments, Stawarska responds, "The pregnant stillness of melancholy can be painful, but it is also often fleeting. There is room to repair."[14]

NOTES

1. Jean Fisher, "Coyote Comes Laughing" (1986), in *Vampire in the Text: Narratives of Contemporary Art* (London: Iniva, 2003), 214–18. If the flaneur is a man who wanders aimlessly, Lauren Elkin reclaims the term to personify a woman (traditionally not given free access to the streets) who wanders purposefully. Elkin, *Flâneuse: Women Walk the City in Paris, New York, Tokyo, Venice, and London* (New York: Farrar, Strauss and Giroux, 2017).

2. Magda Stawarska, conversation with the author, December 6, 2023.

3. Madga Stawarska, in conversation with Lubaina Himid, "Inner Listening: Interpreting the City," *Journal of International Photography*, accessed December 1, 2023, https://www.joip.org.uk/index.php/portfolio/inner-listening-interpreting-the-city/.

4. Elkin, *Flâneuse*, 9.

5. See Peter Halley, "Notes on Nostalgia," *New Observations*, no. 28 (1985); and Alan N. Shapiro, "Gerry Coulter, Sophie Calle and Baudrillard's 'Pursuit in Venice,'" *International Journal of Baudrillard Studies* 15, no. 1 (2018), https://baudrillardstudies.ubishops.ca/gerry-coulter-sophie-calle-and-baudrillards-pursuit-in-venice/.

6. *Kraków to Venice in 12 Hours*, http://www.krakowtovenicein12h.com/, accessed December 1, 2023.

7. Commissioned by TONSPUR Kunstverein Wien and shown for the first time at "Tonspur 59," MuseumsQuartier Wien, 2013; and

subsequently in "Impressit," Harris Museum and Art Gallery, Preston, 2013; Brno International Music- Exposition of New Music, 2015; 10th International Biennial of Contemporary Prints, Liège Fine Arts Museum, 2015; International Print Triennial, Bunkier Sztuki, Kraków, 2015; "Sounding, Resonating and Vibrating," Bludný Kámen, Ostrava, 2017; and "Tonspur 59," MFRU, Foundation Sonda, public installation at Maribor Old Town Hall, 2017.

8. https://www.airpressure.info/, accessed December 13, 2022.

9. Bessel van der Kolk, *The Body Keeps the Score* (London: Penguin, 2014).

10. Pauline Oliveros, *Deep Listening: A Composer's Sound Practice* (Lincoln, NE: iUniverse, 2005).

11. Magda Stawarska, conversation with the author, London, April 13, 2023.

12. Stawarska and Himid, "Inner Listening."

13. Saidiya Hartman, *Lose Your Mother: A Journey along the Atlantic Slave Route* (New York: Macmillan, 2007).

14. Thomas Fuchs, "Melancholia as a Desynchronization: Towards a Psychopathology of Interpersonal Time," *Psychopathology* 34, no. 4 (2001): 179–86.

15. Magda Stawarska, conversation with the author, Preston, July 15, 2023.

Magda Stawarska and her father, Henryk Stawarski, before flying from London to Warsaw, 1984. Photo: Zofia Stawarska

Route 2
East {Hyphen} West

Trauma is not an inviting conversation starter. I cannot bring myself to ask Magda about it. Still, I feel its weightiness, around us, in the work. I write to Magda asking if I may visit her. My choice of words suggests my trip is to alleviate writer's block. I need to observe more things, ask more questions.

EXT. A ROUNDABOUT – MORNING

A white van slams into the back of a compact hybrid car.

I am inside the car that's hit.

My Uber driver is on his phone.

Airbags become hot-air balloons.

The car is pushed into another.

CUT TO:

INT. STUDIO – ARTLAB CPS – EVENING

MAGDA is stitching together footage from a project called *Spaces and Moments*. She stops to show me a video

of her time spent traversing the Bosporus.

She has prepared a worktable at the opposite end of her studio for me to sit at and write.

OFF-SCREEN (O.S.): The pitter-patter of feet, clanging noises of traffic, the whoosh of water, on loop.

I am staring at a painting of a fishing boat that Magda began working on after a residency in Sharjah. She has transposed a photo via a mixture of silkscreen and painting by hand.

I did not know that colors such as pink and violet could appear so muted. I discreetly squeeze some of the paint bottles—her palette—onto the edges of my notebook. An index that I will require later.

INT. A BEDROOM – EVENING

WERONIKA has just engaged in a sexual encounter that seemed to be both maddening and joyous. The scene is in Poland. WERONIKA's boyfriend reaches for her hand and feels a groove in her skin.

She shudders and shoos him away. A scar. A door slammed by a paternal figure. The day she passed her piano exams. Every time I watch this scene, I recall my brother Ali's finger being sliced open by a door and the piercing pain when a shard of glass was removed from my index finger after an accident; there were several.

Found Boat, Lost Memory, 2023 (detail), triptych painting on silkscreen print, Somerset paper. Commissioned by Sharjah Art Foundation

East {Hyphen}West: Sound Impressions of Istanbul, 2015, limited edition vinyl record and artist's book

EAST {hyphen} WEST

— Sound Impressions of Istanbul —

Magda Stawarska-Beavan

From the window, a fairy-tale-like scene in muted pinks, violets, and grays frames WERONIKA.

EXT. STREET – PRESTON – DAY
Magda has painted a sky reminiscent of a J. M. W. Turner picture onto a piece of linen that she has primed and stretched onto a large wooden frame.

I have volunteered to help her carry it out of the municipal studio where she works in central Preston, the Birley, to what she refers to as the print room at the University of Central Lancashire.

My fingers tremble, my nails sink into the edges of the canvas. Descending into the folds of memory—there goes my body. The painting falls down the steps of the backdoor fire escape.

JUMP CUT TO:

EXT. STREET – POLAND – DAY

WERONIKA thinks she might have just seen another *version* of herself, taking a photo of her, VÉRONIQUE?

CUT TO:

EXT. CAR PARK – PRESTON – DAY

MAGDA
It's okay. I do not think that it will fit into the car.

I raise my head. Her eyes are steady and calm.

There is no hint of reprimand.

EXT. STREET – POLAND – AFTERNOON

WERONIKA is singing, a perfectly pitched soprano, her round face angelic.
Water drops beneath one of her eyes: A tear? She may or may not wipe it away.
The rain begins to pour.
But WERONIKA is gleaming—in this moment we almost feel her sense of enlightenment.

CUT TO:

EXT. YORKSHIRE SCULPTURE PARK – DAY

MAGDA and I have been together for two days. I still cannot bring myself to ask her the questions that I'd like to. I try to express this.

> MAGDA
> What would you like to ask?
> Would you like to send an email?

I make excuses and the mumbling ensues. My legs struggle to keep up with hers. Her body, tall and agile, is not quite that of either WERONIKA's or VÉRONIQUE's in Kieślowski's film.

EXT. YORKSHIRE SCULPTURE PARK – DAY

MAGDA is enveloped by bubbles produced by a ginormous bubble-making machine: a cinematic work of contemporary art.

CHILDREN scramble toward her; a toddler is crawling at her feet.

MAGDA stretches out her arms as if about to belt into song.

She swirls more than 180 degrees, not quite a full turn, and smiles to herself before her eyes catch the lens of my iPhone camera.

We march through the woods to an installation by Leonardo Drew.

Her serenity, her methodically placed quiet has returned.

I see the twinned women in Kieślowski's film not as MAGDA's doppelgangers but as one of her containers— a vessel much like the collaborators who engage in her acts of inner listening.

INT. STUDIO – EVENING

We are in a large print-studio complex with multiple, interlocking rooms on a university campus at UCLan. Printing machines resemble guillotines—devices

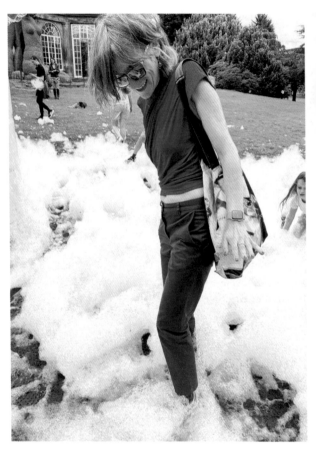

Above:
Magda Stawarska, *Move at Your Own Risk*, 2023, Yorkshire Sculpture Park.
Photo: Blake Karim Mitchell

pp. 54–55:
Some Boats Wait Forever, 2024, acrylic paint on linen, 152 × 100 cm

assembled from across centuries—incubators of knowledge and memory.

MAGDA walks into the reading room where I have been sitting.

> MAGDA
> (performatively)
> I feel that I am not alone in this world!

MAGDA is teasing me by reciting a line verbatim from the movie *The Double Life of Véronique*—a point of mutual fascination. But does *she* feel this way, too?

O.S.: Rachmaninoff's Piano Concerto no. 1—the one that was panned and loathed—is playing.

MAGDA disappears.

I am fumbling with an artist's book from 2015 that Magda produced of her experiences negotiating the politics of the Bosporus while in Istanbul. It is titled *East {Hyphen} West: Sound Impressions of Istanbul*.

The publication is a vinyl record edition. Inside, the liner notes unfold like a *leporello*—an accordion-like painted book. My eyes move along the sheaths of paper. In the center runs a belt, an evocation of the sea printed and cut by hand. But why is it woven into the skin of the page?

MAGDA is standing behind me.

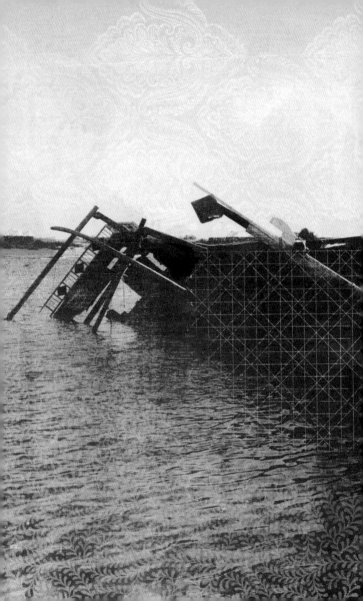

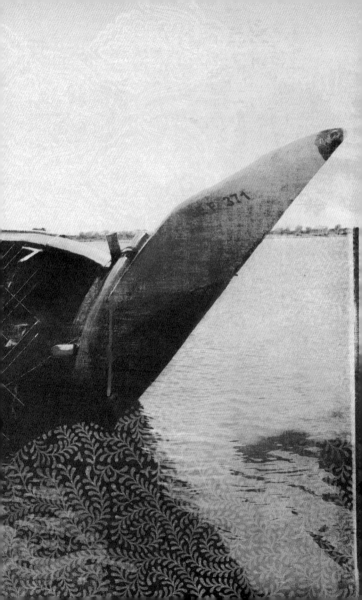

Tenderly, she reaches over my head, to my hands and the table, to the artwork that I am holding.

MAGDA
You see, if someone is brave enough, they can loosen, even unbuckle, the strait.

ME
The strait-jacket?

MAGDA
The sea holds secrets.

This strip of sea, this ribbon of paper is a belt, a shoelace—but could it also be a noose? An intimation of the sea's proximity to perpetual danger? At the back of these pages are scans of the notebooks that Ekin and Lubaina used to write down their thoughts and feelings when listening to her initial composition. Collectively, they translated the city, and with it, the sea.

Although some of these words are heard in the final composition, it feels almost invasive to look at them here—personal handwriting. Private moments, behaviors, patterns.

ME
This feels like a good moment to… ask those questions. The personal ones.

MAGDA is wearing a pink jumpsuit covered in paint.

MAGDA
Okay…

ME
Maybe we begin with why you made
this work?

By this point, I am aware that Magda doesn't like to be
unprepared, but she is (actually) almost always primed.
When she speaks, she often gestures with her hands,
first from her gut; her hands move gradually, with the
delicate ease of someone just about to begin conducting.

MAGDA
Growing up in eastern Europe, in the context that I
did, walking, always walking, I told you who I
walked with. I became perplexed and even a little
obsessed with borders… There was a trip, my first
out of the country, to Leeds; we also visited London.
It was to visit my uncle when I was eight. That was
really implanted in my memory. Recalling places
became a kind of fixation, and with this work, as in
others, I am exploring the space between my body
and the imaginary politics created by a border, but
also the construct: What is "east"and what is "west"?
I was just walking, moving, back and forth, back and
forth. I was thinking no one is touching me, attacking
me, asking for my passport…

ME
Was it a moment of freedom?

16/11/14

Istanbul
to
Zibar
an
airport
ride...

Floating & sparkling
rolling and running
wide park
barking & howling
quacking & calling
st lves seagulls
little children chanting
scream

lapping slapping
waters swishing
than children begging
cross calling
shouting

men in castval
wide open spaces
skies birds water

smoking motor verging
smell the diesel
the the blue smoke

horn — more
metal ducking
other ducks
geese

between cars
silly thing
real horn — loud &
long
boat — bossy

men oding bread
type auctions

con, con, con
another busy address

floating through streets
and time softly

meeehooooo
mist brib

smoky men
look at me
same
I am here
energising
buy my stuff
its cheap
buy my stuff

helicopter skies
wide horizon hot air
busy busy stuff

swishing ducking whizzing
sweeping persian
carpet street
arab/indian violin
usual busy woman on
the intercom — go where
— go where
slot machines
beeping bleeping
jackpot
fast
tapping like mice could
tiramisu? or a little
of wooden ball banno
in a clear tube

MAGDA
No. I mean, it became banal. The result is a
performance, one that involved and encompassed the
lives of many individuals in the end. The "crossing"
is a metaphor I return to a lot in my thinking.

ME
Is there a biblical connotation here? Tied to the
politics of where you grew up?

MAGDA unlatches and refastens her jumpsuit and
reminds me that she must tidy up so that I can rest. I had
been in a car accident earlier that day after all.

The weight of politicized breath, at first, seems to be a
space from which Magda will run, even escape from
directly discussing. But like the hidden pages meticulously
sewn into *East {Hyphen} West*, the traumatic, the suspect,
the nation finds its place in the intimacy of the fold. That
is because for Magda, intimacy is one of her many
strategies of resistance.

pp. 58–59:
Sound Impressions of Istanbul [Istanbul, Zanzibar or Preston or London], 2016, digital print on BFK Rives, 100 × 70 cm

Above:
Boulevard Anfa, 2019, painting on silkscreen print, Somerset paper, 200 × 130 × 25cm.
Photo: Steve Tanne

Following page:
Blake Karim Mitchell, *Slow Days in Lamu*, 2023. Photo: Omar Kholeif

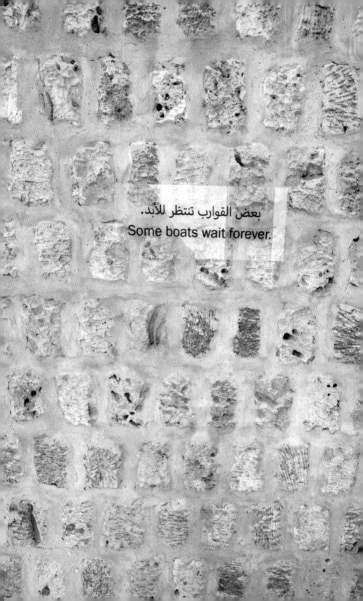

بعض القوارب تنتظر للأبد.
Some boats wait forever.

Route 3
Trans-Atlantic:
Walking Toward an Exit Route

What kind of life is it always to plan
And do, to promise and finish, to wish
for the near and the safe? Yes, by the
heavens, if I wanted a boat I would want
a boat I couldn't steer.
—Mary Oliver, "If I Wanted a Boat"

Magda was discussing someone named Mary Oliver in the
minivan.
"Which Mary Oliver?"I asked.
"That's a long story,"a voice interjected.
We were drifting in our individual mindscapes.

A minibus had taken us through the sandstone
mountains of Hamriyah in the emirate of Sharjah, through
the emirate of Fujairah, and across to the mangroves of
Kalba on the Gulf of Oman. I explained to Stawarska that
Sharjah is the only emirate on two coasts. Before I could
complete my sentence, Stawarska had taken off with her
Canon 5D full-frame camera. I hopped back into the
vehicle and gestured for the driver to catch up with her.
Stawarska was on a pier photographing a gigantic
boat. Moored to a rickety wooden jetty, it had assumed a
life of its own. Fishnets were splayed across its center.
A crack had fractured the vessel—floating, now out of
use. Perhaps inflected by our conversation, the boat

resembled a sculptural readymade. A work by a conceptual artist such as Christoph Büchel, Mike Nelson, Jeremy Deller, or even Joseph Beuys. Stationed here, the tide out, resting on the seabed, waiting for the water to usher in another day.

Concerned for Stawarska's safety, a colleague rushed into the water to assess to stability of the pier. It was solid, he informed us. The flaneuse before me was not in the least bit anxious, nor was she naive in her movement.

When I queried her interest in the boat, the artist quickly changed the subject. We veered into discussing historical examples of women artists who wandered purposefully. I recounted what I knew of the Welsh painter Gwen John, for whom meandering in nature, a site of kinship, offered solace. We spoke of our fondness for Georgia O'Keeffe's watercolors and a desire to visit New Mexico to breathe in the landscapes that affected her. In *Windswept: Walking the Paths of Trailblazing Women*, the writer Annabel Abbs details how O'Keeffe "longed" for the "fullness of emptiness" of the plains and wide sunsets, which allowed her to access her "innermost being."[1]

Stawarska spoke about her fondness for 1980s performance art—Ana Mendieta, Judy Chicago, and conceptions of the "ordinary woman." Mona Hatoum's name fell out of my mouth in response. I outlined Hatoum's untitled 1985 performance for the Brixton Roadworks Collective, in which the artist walked barefoot through the streets for nearly an hour, shackled by Doc Martens boots—at the time a symbol associated with the police and skinheads. Ten years later, Hatoum produced *Performance Still*, an emblematic image of her feet

dragging along the boots. We decided that Rebecca Solnit's cultural treatise *Wanderlust: A History of Walking* (2000) was the first book for our new reading group.

I segued to Fouad Elkoury's *Suite Égyptienne* (1985–98), a multiyear project that involved the Lebanese artist and photographer tracing the steps of the mythologized flaneurs Maxime Du Camp and Gustave Flaubert, both French male literary figures with the privilege to move through Egypt's streets and sites while it was under imperial rule. Marked as the subject of the occidental gaze, Elkoury has us look again at scenes and settings, considering our complicity as a viewer. Around the same time, the Turkish artist Nil Yalter produced the video installation *Pyramis: The Voyage of Eudore* (1987). For this work, the artist followed the tracks of François-René de Chateaubriand, the French author, historian, and aristocrat, in Egypt, filming with a VHS camera borrowed from an arts festival in France, where she lives and works. Yalter's multichannel installation fragments the western imaginary across multiple cathode-ray TV screens.

Stawarska moved from the subject of walking to crawling—crawling as an act of resistance, of duration, conversation, and invitation. Pope.L's feats of endurance crawling through the streets of New York, which he began in the late 1970s, found unusual resonance in Amal Kenawy's *The Silence of the Sheep* (2009, also referred to as *The Silence of the Lambs*), for which the artist hired a group of day laborers to crawl across downtown Cairo in the middle of the day. The documentation of the performance, subsequently shown in art biennials and group exhibitions worldwide, reveals stunned bystanders

verbally accosting Kenawy, who was walking alongside the performers, leading them. The result is an exposition on the meaning of art. The artist resists each verbal attack, seeking to create a meaningful critical context for those who prick and prod her.[2]

By the time we concluded our conversation, we had finished the lunch we had brought and made our way back to Sharjah's city center. The excursion got me thinking about a work by Stawarska that I had seen at the New Museum in New York in 2019. Taking as a starting point Lubaina Himid's *Metal Handkerchiefs*, Stawarska initiated a conversation piece entitled *Reduce the Time Spent Holding* (2019). Banging, clacking, sewing, stitching, soldering—sounds that animate behavior and action. We listen in an intimate way via headphones as we sit opposite the large window overlooking the Bowery, where a voice at once authoritarian and caring encourages us to listen intently.

Her soundscape for Himid's *Old Boat / New Money* (2019), an installation of painted wooden planks leaning against a wall, envelopes us within the expansive gallery, where the creak of wood meets the gurgling sound of water, the whooshing of the tide. We are in a shipyard. Is this still a museum space of innovation and communion, or a site of danger?

Several weeks after the Sharjah trip, in Stawarska's studio in Preston, half a dozen pictures of boats, or specific parts of the vessels, are silkscreened onto paper and hand-painted by the artist in oils.

"That's the boat from Kalba!" I exclaim.

"No, that's another one, from Mina Khalid Port in

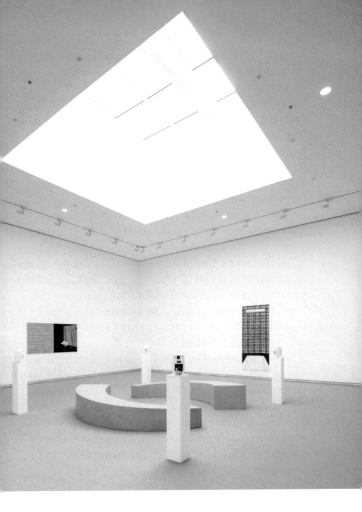

Plan B: A Libretto, 2023, 4-channel sound installation, 13 min. Devised in collaboration with Blake Karim Mitchell, John Labib, and Moe Choucair. Commissioned by Sharjah Art Foundation

Sharjah," Stawarska says. "It's a fishing boat in waiting."

Stawarska discusses the boat as a found object—one captured in the aperture of her camera lens. The lived experiences of this boat might continue to exist in its hull—in the wood of the container—or they might have been lost at sea; it does not preclude this vestige from having had a life or indeed an afterlife of its own.[3] Is it one wedged in the archive of ruins or made animate as an imagination of the lost and dispossessed? Stawarska's found boat will soon become part of a two-person exhibition with longtime collaborator Himid at Sharjah Art Foundation. In the exhibition "Plaited Time / Deep Water," the question of the boat as a vessel with a myriad of intents—one tethered to lives lost aboard ships, comes to the fore. Exhibited for the first time, the image of this vestige is splintered, displayed as three separate hand-painted silkscreens, with a narrow gap between the framed pictures. A fracture, a type of expression, tethered to the Freudian concept of the "fractured self"; aftereffects haunt the public imaginary of the artist's native Poland, a site for many, specifically the Jewish diaspora, associated with the erasure of human life.[4] Here, the fractal is a wreck reconstituted and soldered, a method of "encountering a past that is not past"[5]—an afterlife to the colonial conditions of the local audience, who are mostly diasporic individuals from East Africa and South Asia.

Outdoors on a warm November morning at the Sharjah Art Foundation, Stawarska's *Lost Boat, Found Memory* (2023) is flailing in the wind. It is part of "Plaited Time / Deep Water," an exhibition of work by

Stawarska and Himid. Stawarska's reimagining of this body of movement has been exploded beyond life-size. Digitally printed on recycled, heavy-duty cloth, it is not a readymade, proportioned to the wall, the tight close-ups of details of the vessel present a visually jarring relic crafted for an open-air museum, exposed to the elements. It is draped from the roof of a building in Sharjah's heritage area within the old city gates. Across from it hangs a sign on a coral wall that reads "Some Boats Wait Forever"—words I had spoken to Stawarska on the bus back from Kalba nearly a year before. While some bodies long for the proximity and comfort of the concept of home,[6] others find life through a map, tracing new routes.

NOTES

1. Annabel Abbs, *Windswept: Walking the Paths of Trailblazing Women* (London: John Murray Press, 2022), 56–68.

2. See Dan Jakubowski, "Provocative Acts and Censorial Revisions: The Many Antagonisms of Amal Kenawy's *The Silence of Lambs,*" *African Arts* 50, no. 4 (2017): 24–33; and Rasha Salti, "The Wiles of Spring," *Film Quarterly* 75, no. 2 (December 1, 2021): 49–58.

3. With reference to the term the "afterlife of slavery," which Saidiya Hartman uses to describe "the skewed life chances, limited access to health and education, premature death, incarceration, and impoverishment" created by slavery's "racial calculus." Saidiya Hartman, *Lose Your Mother: A Journey along the Atlantic Slave Route* (London: Macmillan, 2006), 2–54.

4. Matthew C. Altman and Cynthia D. Coe, *The Fractured Self in Freud and German Philosophy* (London: Palgrave Macmillan, 2013), 1–7.

5. Christina Sharpe, *In the Wake: On Blackness and Being* (Durham, NC: Duke University Press, 2016), 11.

6. Magda Stawarska, conversation with the author, Freud Museum, London, October 13, 2023.

Above:
Oranienburger Straße, 2019, painting on silkscreen print, Somerset paper, 200 x 130 cm.
Photo: Steve Tanner

pp. 72, 73:
Lost Boat, Found Memory, 2023, digital print of a painted silkscreen triptych
9000 × 2000 cm Commissioned by Sharjah Art Foundation

Route 4
To Zanzibar

The color of that distance is the color of an emotion,
the color of solitude and of desire, the color of *there*
seen from here, the color of where you are *not*.
—Rebecca Solnit, *A Field Guide for Getting Lost*

"If I need to run, I will run in the rain," Magda says.[1]

"Through a swamp?" I ask, somewhat facetiously.

"If I need to run, I will run," she responds steadfastly.

Magda begins to outline visions conjured by the
Polish seaside city of Sopot.

"My parents gave me a T-shirt when I was young
that had a sailing boat on it. The boat was *Dar Młodzieży*,
a Polish sail training ship designed by Zygmunt Choreń.
I loved the sails."

On this trip with Magda around the edge of the
Preston train station, we discussed death, in obtuse
ways; language did not find its form.

I had just returned from a visit to see a newly
installed iteration of *Zanzibar* (1999–2023), a collaboration
between Stawarska and Lubaina Himid commissioned by
Nick Aitkens. After landing in Eindhoven, I was picked
up by a driver from the Bonnefanten in Maastricht who
was taking me to install an exhibition of the Syrian
Armenian artist, Hrair Sarkissian. The chauffeur regaled
me with tales of celebrity visitors. On the way, I asked if
we could make a pit stop to see a show at the Van

Abbemuseum in Eindhoven. The car screeched to a halt in front of what seemed to be a service entrance to the museum. I walked in bewildered, but with purpose.

"Do you know where I can find the artwork *Zanzibar*?" I queried at the desk. No response.

"It's part of a show curated by Nick Aitkens, 'Rewinding Internationalism.' "Another beat.

"It has music, opera, and paintings!" I asserted.

"Aha!" responded the strawberry-blonde gallery attendant standing in the foyer behind me.

"Women's tears fill the ocean!"she muttered. Are you the artist?" The attendant queried.

A beat.

Her eyes widened.

"Do you know the artist?"

"...Of *Women's Tears Fill the Ocean*," she continued."

The sound of a repetitive thumping ushers me back to the present. Magda is attempting to assist me with my suitcase, which I maintain that I can roll on my own as we continue our afternoon walk.

"It certainly felt like you were running through the rain with this piece," I said.

"It was a complicated process. A fun one. It involved going back. It involved asking Lubaina to elaborate on things such as her mother's rosewater. I tried to smell the cloves in *the* paintings. And then there were hours spent in the British Library and the BBC sound archives, reflecting on mid-twentieth-century life in the UK."

"Did you feel it was especially painful,timing-wise?" I asked.

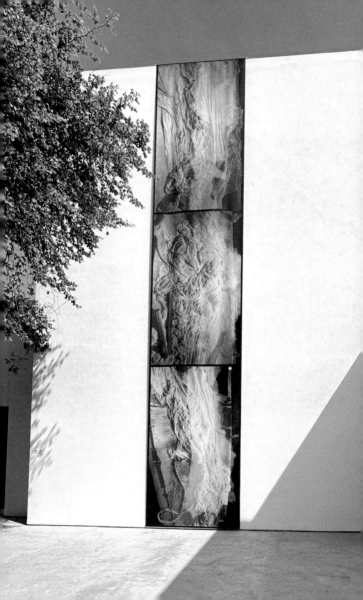

Thirteen Zero Nine Zero, 2021, multimedia installation, dimensions variable. Installation view: "Invisible Narratives²,"Yamamoto Keiko Rochaix, London. Photo: Alexander Christie

Lubaina's mother had passed away right before Magda's father. *Zanzibar* involved a haunting—the absence of Lubaina's father, and the colonization of Zanzibar. I felt that this work was a breakthrough. It had grabbed me by the hand and ushered me into someone's inner life.

Magda pursed her lips gently before speaking. "The work emerges from a collaboration. From those moments when you discover that what you had in mind is different from your reality. That the connections between places are all connected to time. Time as in the beat, the space between a song, a breath, a memory, a story—is found between paintings—pictures that have been taken off the wall and that now live floating in space."

"Connections between distances are skewed," I responded.

We found ourselves back at the Birley, where Magda had reserved a room so that I could experience the full thirty-eight minutes of *Zanzibar* on eight channels of sound (although without Lubaina's paintings present), uninterrupted by museum distractions.

I sat on the floor; peering out the windows, I caught another bout of melancholy. I often speak when it is more appropriate to remain silent. When in the grip of grief, I fumble the words, or they amble out of my mouth in a stutter, without the hoped-for sophistication.

I contemplated the life of Magda's father. He was a telecommunications manager with an interest in physics and networked technology. He began his career working on electronics programs for Poland. His interest in human networks and electrical currents bore a kinship to Stawarska's orthography of walking.

Later in the week, we are having dinner at a Polish restaurant in Manchester. Here, Magda relayed the phenomenological aspects of relistening to an audio recording when she was little.

"The first time I started recording... I had switched on the recorder the evening before. I started to listen. I heard something, not silence, but instead the rhythmic purring of a cat, the distant ticking of a clock above the fireplace in a living room. Things that I had never noticed before, and, eventually, I felt my own heartbeat."

Heart—
beat

She paused, her hands clasped against her chest, as if keeping her heart from falling out.

Magda Stawarska was born at 2:10 pm in the 1970s in Ruda Śląska, a city in the metropolitan region of Katowice. When recounting the story of her birth, Magda explains that her mother had gone into labor the previous night. Her mother's surgeon was a family friend, which she attributes as a subconscious link to her interest in water, movement, and boats. There was a kerfuffle of some sort that evening. A disagreement between husband and wife, and she was born. Katowice and its surroundings, where Stawarska was partially raised, had most of its historical monuments destroyed by Germans during the Second World War, including its synagogue.[2] Tracing the shape of the ruin would become a part of Stawarska's process of continuous search, of unearthing.

The desire to resuscitate narratives that have been silenced, or in some cases bludgeoned, has been part of Stawarska's work since the beginning. With *Zanzibar*, this generosity extends to Himid. As we prepared to install the exhibition "Plaited Time / Deep Water," in Sharjah, Himid said to me, "This is the first time that I feel I am truly seen." *Zanzibar*, a suite of nine diptych paintings created by Himid after a return to Zanzibar in 1997, narrates a deeply personal aspect of Himid's life story. It involves the resuscitating of a life that was left behind when Himid's mother traveled to England in 1954 after the unexpected, tragic death of Himid's father from malaria when Himid was a few weeks old. Through a dialogue with Stawarska, *Zanzibar* becomes a different work. The paintings are removed from the walls, and encased in a score composed by Stawarska that encourages the visitor to perambulate. The work becomes a site of communal becoming. The deep sadness finds relief. Melodrama is interspersed with humor gleaned from inside the realm of culture's often obtuse vaults—through the voices of BBC Radio 3 news presenters as well as the inner voice of Himid, Himid notes was enabled by numerous supportive exchanges with Stawarska. The visual departure points are Himid's painted diptychs of shutters, seashells, and rosewater— abstract, seeping, leaking. Likewise, the audience, who stands behind these paintings to listen, becomes concealed, their bodies bisected by the enormity of the canvases that float throughout the gallery spaces.

Bearing witness to the trauma of loss and diasporic life in the mid-century, and the ruptures it produces, is a

something that Stawarska and Himid have in common with Hrair Sarkissian, whose large-format photographs, audio documents, and video works summon pictures of the dispossessed—images where violence is all but withheld. Such is this case for those executed in public squares by a military regime, as in *Execution Squares* (2008), or individuals who live in the constant flux of "aliveness," a perpetual death in motion, as evinced in his panoptical series *Last Seen* (2019–21).[3] The latter is a photographic installation produced in five countries: Argentina, Bosnia, Brazil, Kosovo, and Lebanon. Working with local NGOs, Sarkissian sought out families whose children, husbands, and relatives were deemed to have disappeared, suspended between life and death. With one single photo, he captures an empty scene where the families remembered last seeing them. In the still and quiet of these empty frames emerges the howling scream of ghosts.

Back to the scene—listening to *Zanzibar* in Preston. I hear rainfall rising at the edges of the room, ushering me to a voice—Himid's. A second voice, a little deeper, leads me further into the depths. The timbre is male. I recognize parts of the text from a catalogue accompanying an exhibition at Mostyn in Llandudno, Wales, in 1999. The words are pulled from a guidebook that Himid's Comoran father gave her white English mother before traveling to what was then the Sultanate of Zanzibar in 1954. This scene would become a tragic setting for Himid and her mother, then twenty-six years old. Her father died when he was just thirty-three years old. Himid, a newborn, her mother's companion. In *Zanzibar*, Himid's

Lubaina Himid and Magda Stawarska, *Zanzibar*, installation view, "Rewinding Internationalism," Van Abbemuseum, Eindhoven, 2022. Photo: Joep Jacobs

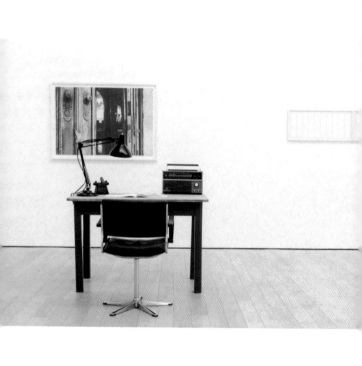

Translating the City: Sounds of the Sea, 2019, mixed-media installation. Installation view: "Invisible Narratives: New Conversations about Time and Place," Newlyn Art Gallery. Photo: Steve Tanner

voice is commanding as it undulates across the sounds of East African music, opera, commentary from BBC Radio 3 presenters, and mid-century British newsreel footage.

Stawarska's thirty-eight-minute audio documentary is an affective, dyssynchronous evocation of a life lived, lost, and recovered. I gravitate from speaker to speaker, finding myself, like others, whether in Preston, Eindhoven, or Sharjah, within the folds of Himid's memory. Some stand holding back tears listening to the soundscape, standing behind Himid's floating paintings as shields, where the title of each diptych is penciled onto the back of the linen paintings, each a poem unto itself— *Shutters Only Hide the Sun*, *Women's Tears Fill the Ocean*, *Rain Cannot Wash Away Memories*. The titles serve as an anchor when gazing at the paintings as they gently swing with the air of the gallery's controlled climate.

As the literary scholar Kevin Quashie writes in *Black Aliveness, or a Poetics of Being*, the notion of "presence" occurs through a simulation where one can bear witness to Black life *as it is*.[4] *Zanzibar* allows for the specificity of a Black life through an act of entangled reflection, forging a counterpoint, a space where shadows exist "in the wake" of the Black erasure in Britain during Himid's early life, materializing an individual form of Black visuality as opposed to a generalized aesthetic of Blackness.[5] *Zanzibar* offers Himid a site or forum of "becoming," one achieved without the burden of linear or pure chronology—an aspect that both collaborators often seek to skew.[6] Listening to *Zanzibar*, we are also listening to Stawarska listening to Himid, and in turn to

Himid listening to the grief of others, whether it is her favorite operas or the news of pasts resurrected, as she negotiates a loss that shaped the way she would come to see for the rest of her life.[7]

The tender groove, the intaglio, meaning "to incise or engrave," common to the practice of printmaking, a regular practice for Stawarska, enables her to locate her subject through a call-and-response. Stawarska engraves Himid's memories, allowing the spectator to function as a subject maneuvering space and time simultaneously. The installation's impact is derived through the incandescent prospect of touching—feelings of a life lived, mislaid, and sewn back together.

The relay of voices featured in *Zanzibar* speaks to Stawarska's interest in accentuating the notion of the collective. The listener-spectator hears the tragicomic opera *Der Rosenkavalier* and correspondence between its composer, Richard Strauss, and the opera's librettist, Hugo von Hofmannsthal, as narrated and annotated by a BBC presenter. The genteel male voice of the presenter alerts us to the "wenches in men's clothes," and how the mere "sight of an ankle"—flesh—could set the crowd ablaze. The way mid-century life in Britain unfolds is handled delicately. A broadcaster announces Princess Margaret's visit to the new Christian Dior collection, where top models will be seen representing the "H life." Is this the "horrid" or the "heavenly" life, interrogates the presenter wryly, almost boldly.

Spoken words appear and disappear in a loop, without hierarchy, but the thrust of the story, the revelation, appears when Himid poses the question: "I like to think

that somehow there has been some sort of revenge for this lifetime spent without my father."

In the third and final act, Himid's voice continues to tug at us: "How has it happened that both the sea and women's tears are made of saltwater?" She continues: "Is the sea living inside us? Waiting to pour out? Or it could be that so many women have cried as they stood on shore looking out?" The bitterness in the sweetness of the female experience. A crescendo of women's voices forms a protective shroud that brings us back to where we first began, with the rainfall.

NOTES

1. All quotes by the artist are gleaned from audio recordings captured between September 2020 and December 2023.

2. See https://www.jewishgen.org/yizkor/Katowice/Katowice.html, accessed December 26, 2023.

3. Here I am invoking Kevin Quashie's concept of "Black aliveness." See Kevin Quashie, Black Aliveness, or A Poetics of Being (Durham, NC: Duke University Press, 2021).

4. Quashie, 15–31.

5. Christina Sharpe, In the Wake: On Blackness and Being (Durham, NC: Duke University Press, 2016), 1–25.

6. Michelle M. Wright, Becoming Black: Creating Identity in the African Diaspora (Durham, NC: Duke University Press, 2004), 27–65.

7. Lubaina Himid, in conversation with Griselda Pollock, "On the Pleasures of Opera," in Lubaina Himid, ed. Michael Wellen (London: Tate, 2021), 16–40.

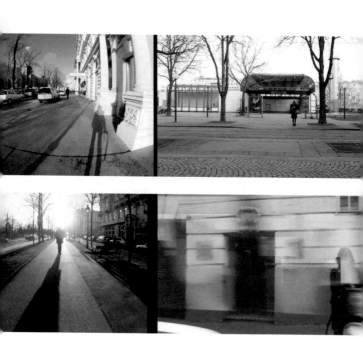

Still images from *Who/Wer,* 2017, two-channel digital video with quadrophonic sound, 16:35 minutes

Route 5
Cutting across London and Vienna

No need to drive a nail into the wall
To hang your hat on;
When you come in, just drop it on the chair
No guest has sat on.
—Bertolt Brecht, "On the Term of Exile"

It is the thirteenth of a busy month, and I am meeting
Magda at Euston Station in London. We have plans to
visit Camden Arts Centre. I hoped its outdoor café would
offer a moment to clear our heads, and to reflect on the
titles of new artworks for an exhibition being prepared
for summer 2024 at Keiko Yamamoto Rochaix gallery in
London. Titles are a pivotal reference in Magda's work.
Her compositions are constituted through acts of
layering and building. Her use of language could be
conceived like constructing an open-ended poem, each
work's designation is a new stanza—*Mother Tongue,
Resonating Silence, Transliteration*, to name a few.

I map out a route to our destination, but within ten
minutes our path starts alternating back and forth, the
app on my phone constantly rerouting. This is, as I have
come to learn, how Magda navigates the city—as her
interest peaks in one direction, the invitation to get lost
becomes inevitable, segueing us into a space where one
becomes unmoored from the construct of the destination,
homing in on the journey. Reformulating plans, paths,

videos, or soundscapes—the act of revisiting and reconstituting—is part of Stawarska's process. We find ourselves near slow-moving water, reflecting on the author Deborah Levy's "living autobiographies"—*Things I Don't Want to Know* (2013), *The Cost of Living* (2018), and *Real Estate* (2021). Levy's excursions guide us across Camden. Her self-reflexive trilogy, inspired by George Orwell's essay "Why I Write," speaks to the pleasures and burdens of navigating an artistic life while also negotiating the experience of womanhood. Motherhood, financial difficulty, and the very concept of how a woman constructs a "room," and in turn, the possibility to create a world "of her own," to invoke Virginia Woolf, has bound us both to Levy. We had picked up the first volume here in Camden, where Levy reportedly lives. Stawarska's eyes wander around me, across redbrick mansions, wondering which might best resemble the descriptions of the author's home.

Two hours have passed since setting off. We are near but not there. We have been sitting, standing, gazing. I am panting. Magda queries my opinion about almost everything I look at.

"Hold on, I thought I was meant to be the one asking the questions!" I interject.

Magda grins. A detour has been agreed upon, at the Freud Museum. To my surprise, Magda has never been. She maneuvers us inside, where she begins narrating her experiences of making and exhibiting art in Vienna between 2014 and 2017.

"The Freud Museum in Vienna is virtually empty in comparison to this," she notes.

Who/Wer, 2017, two–channel digital video projection (16:35 min.) onto drawing on paper and silkscreen print. Installation view: "Cross Cut," projektraumMAG3, Vienna, 2019

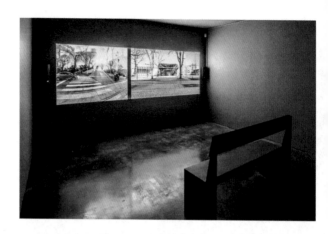

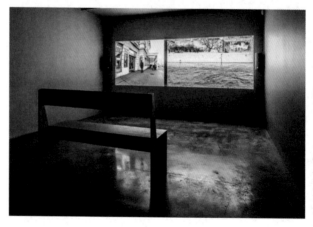

Who/Wer, 2017, two-channel digital video, 16:35 min. Installation view: "Sounds Like Her: Gender, Sound Art, and Sonic Cultures," curated by Christine Eyene, New Art Exchange, Nottingham, 2017

I had perhaps naively come to believe that Freud had lived the better part of his life in this house. But I came to understand much of the museum is a reconstitution of sorts—replicating his home in Austria. Sigmund Freud had only lived in London for just over a year before he died. This house museum is as much a remnant of his youngest daughter's life, the psychoanalyst Anna Freud, who lived there for forty-four years. A detail that I had failed to note over the course of my visits, fascinated as I was with Freud's collection of artifacts, not least his famous couch.

We sit outside. Stawarska is crouched near a bed of flowers. Smoke from my cigarette blows into her face, but she says nothing, engrossed in thought.

"The most important thing is to remember that Great Britain offered the Freuds asylum when they needed to flee persecution."

At 20 Maresfield Gardens, we acknowledge our mutual status as diasporic individuals—citizens of nowhere, in a constant state of exile, imposed or otherwise. Stawarska's adopted persona as a flaneuse, who when stopped and queried of her identity, may respond with the truth, elide the question, or conjure a fiction. Traversing geographic boundaries, her body is a container, personifying multiple avatars, code-switching dependent on the context in which she is making art. We have discussed parallels with the art of Lynn Hershman Leeson, the pioneering American artist who, from 1973 to 1978, took on the identity of the invented character Roberta Breitmore, which allowed her to access a more exclusive realm of financial privilege.[1] Similarly,

Stawarska's persona bears a certain resemblance to that of Sophie Calle, whose performances have seen her become a hotel maid or surveille strangers; her "private games," as she refers to them, are usually constructed around a set of predetermined constraints.[2] Magda too, I come to learn, imposes constraints on her person, even the practice of getting lost.

We arrive at the Camden Arts Centre café a couple of hours later than planned. We follow our discussion of Freud and Vienna by reflecting on Stawarska's *Who/Wer* (2017), an installation I had seen at Nottingham's New Art Exchange, in the exhibition "Sounds Like Her." The work is a split-screen installation composed of flickering black-and-white pictures that accumulate. The work involved Magda "following" the Austrian playwright Wolfgang Kindermann on various routes. A shadow that did not reveal herself, she used the experience to create audio recordings, photographs, and video of Kindermann's usual routes around Vienna. Kindermann subsequently produced several texts in response to Stawarska's recordings, which inflected the way in which the narrative was to unfold. It was initially titled *To Follow: Who/Wer*. Black-and-white pictures present a figure with Magda's shadow, as if stalking, invading her subject's life. Moving images flicker as voices are heard, voiced in accents and a tessitura that jars. Whose words are these? Where do they belong, and what do they reveal?

"I wanted to consider the threshold between the real and imagined history of the place that a person assumes so well," Stawarska told me.

Above:
Magda Stawarska self-portrait outside Wiener Konzerthaus, Vienna, 2015

Following page:
Ulica Zofii Sadowskiej, 2022, painting and silkscreen print, Somerset paper, 105 × 140 cm

Alongside her two-channel video, Stawarska developed a series of photographs printed as silkscreens in gray and blueish hues. Each photograph resembles a drape—a protective curtain that swathes or conceals histories that have not been attended to. The artist's affinity with detective fiction, I am informed, influenced the lurking aesthetics of the work. Detective fiction tethered to the historical moment it emerged in the 1800s, at the same time as the Industrial Revolution. Some examples that we discuss include Voltaire's *Zadig, or The Book of Fate* from 1747, one of the original references to the genre. The book deals with the life of an exiled person as they search for the answer to a looming mystery, namely their fate. But perhaps more than anything it is Warsaw, Poland's mythologized notion as the capital of crime fiction—a place where spies, disenchanted lawyers, and novelists convene that may have influenced her most.[3] Beyond jokingly referring to "a strange murder-mystery set in Poland," we do not venture any further. As sunset approaches on today's journey, so too does our conversation come to an end.

NOTES
1. Peter Weibel, *Civic Radar* (Ostfildern: Hatje Cantz, 2016), 16.

2. Sophie Calle, *True Stories*, 7th ed. (Arles: Actes Sud, 2023), x.

3. Adam Mazurkiewicz, "Polish Crime Literature after 1989," *Belphégor* 20, no. 1 (2022), http://journals.openedition .org/belphegor/4894.

Or just walking

Was she on the train or an automobile,

I find solace in the tranquil peace surrounding me.
Yet, amidst this serene daydreaming, triggers jar me awake
— Symphonies and rhythms of construction, destruction,
and the relentless speed.

Route 6
Lost and Found in Sharjah

Even though I have not heard
the golden decibels of angels,
I have been living in a noiseless
palace where the doorbell is pulsating
light and I am able to answer.
—Raymond Antrobus, "Echo"

Tessellating patterns shimmer and float on thin but
rugged Japanese paper. Each of three sheets moves
with the exhale of each breath. We are in the first of
Sharjah Art Foundation's Al Mureijah Square galleries,
where Stawarska's *Lost and Found* (2023) has been
installed as an amalgamation, or echo, of memories and
journeys that invoke the emirate of Sharjah. The
installation is composed of two works, *Patterns of
Al-Andalus* (2023) and a reimagining of an earlier piece,
Ida (2022–23). The latter is inspired by the protagonist
of the eponymous 1941 novel by Gertrude Stein. Rapid
movement is conveyed through the spinning of three
slide-carousel projections of text and image. The
restless, precocious character of Ida becomes an
incarnation through which Stawarska explores the
topography of Sharjah. Seasons, prayer times, and
public holidays dictate the nature of these journeys. In
the images, shop stalls stand closed, sheathed in layers
of different fabric. Boats sit moored, each covered in

their own form of drapery. In the galleries, Stawarska lays bare her process on the wall:

Ingredients, Lost and Found:
Patterns of Al-Andalus
A palimpsest.
Hours of walking the streets of Sharjah on quiet days and busy evenings while listening and looking at the shape, color, and fabric of the city.
Weeks of studying the photographs to find the most breath taking images of intense emptiness and unusual quiet.
Days of reading texts made by a collaborator who listened to noisy evenings with the ear of a resident.
Hours of thinking about and then mixing screen printing ink thirty shades of blue.
Weeks and weeks of silk screen printing, layer upon layer of pattern, on both sides of four delicate rolls of Japanese paper—meters upon meters.
A lifetime of fascination for codes and patterns, cities and influences, architecture and language.

Echoes of architectural motifs, of details found in the streets of Sharjah accumulate to fashion codes—ones unspooled—left bare for endless construction and deconstruction by local audiences who will notice intertextual references—patterns familiar and unfamiliar to them. Propositions of a utopian era of harmonious coexistence that is no longer.[1] In this perfectly square white room (we refuse to call it a white cube because of the small door that occasionally leads to a kitchen),

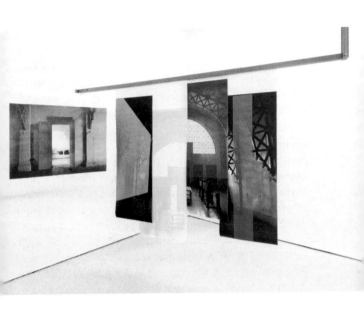

p. 94:
Selected slides from *Lost and Found*, 2023. 240 slide projections on three carousels, duration variable. Fragments of text from *Ida* by Gertrude Stein, and Souraya Kreidieh. Commissioned by Sharjah Art Foundation

Above:
Brcka 40, from *Spaces and Moments*, installation with paper and wooden structures, screenprints, and digital print on Awagami Washi paper, 4-channel audio. Installation view: Yamamoto Keiko Rochaix, London, 2020. Photo: Alexander Christie

Stawarska has continued to stitch together geographies of other people's imagination. Projected from a slide carousel onto the patterned architecture:

Wounds require salt to be rubbed in.
To cleanse, before they may heal.

The notion of the avatar offers a means for Stawarska to assume the role of conductor, a convenor of ecologies buried in sand. In the sound piece *Plan B: A Libretto* (2023), the artist revisits a series of paintings by Lubaina Himid entitled *Plan B* (1997). Developed by Himid during a residency in the English seaside town of St. Ives, these diptychs contain poems by Himid of movement, loss, and exile alongside vivid and colorful vestiges of water. At times, these are painted alongside empty buildings, which evoke a historical moment when war barricaded the sea, hollowing the St. Ives coastline of its lure and luster. Beneath a thirty-feet-high skylight, two arched benches offer visitors multiple perspectives for listening to the libretto and looking at the paintings. A relay between two seemingly male tenors emerges, overtaking the sound of crashing waves, which Stawarska recorded in St. Ives.

The libretto, in Arabic, is not a translation of the poems found in the paintings, but an interpretation. Stawarska and Himid invited John Labib and Blake Karim Mitchell to write it. Both from Alexandria, Egypt, and living in Dubai and Sharjah, respectively, they deployed their mother tongue to explore the possibilities of language to stretch, expand, and contaminate its

potential meaning. Speaking in a vernacular Egyptian Arabic native to their coastal city—which they lament as a disappearing dialect—the resulting libretto layers one coastal city on another, offering reprieve, possible salvation, for a disappearing coast, for the withering imagination, seeking to resist cultural erasure, to chart a new course.

NOTES

1. With the title *Patterns of Al-Andalus*, Stawarska is invoking a historical period of the Al-Andalus states (711–1492) in the Iberian Peninsula, parts of which are now located in Spain, Portugal, and France. The most significant vestige is the region today known as Andalusia. The era of Al-Andalus is often referred to as a period of coexistence, where Muslims, Christians, and Jews lived side by side for centuries. A significant visual remnant of this time is the architecture, as well as the tiles and patterns of Andalusia, one whose visual motifs echo across Africa and Asia. Their traces, found in the streets of Sharjah, inspired Stawarska's silkscreen patterned work. See Montgomery Watt, *A History of Islamic Spain* (Edinburgh: Edinburgh University Press, 1967), 31–32.

25

Is pruisisch blauw de kleur

L'outremer

azuurbla

le bleu
BLAUW

Baby
BLA

Interlude
Myths of Blue

and so over ocean
…
weathered by a toneless
sky grey/
mulatto…
i stroke and there's water
we're drowning and i…
—Gboyega Odubanjo, "From Swimming"

Songs are like tattoos—

I sing from intelligence!
—Nina Simone

The scales and range of a contralto.
A fata morgana.
They,
a prospective lover,
they once argued that one must want to have a body.
But what is it to dream *with* a body, *without* organs?
Blue is the color of my true love's hair, I sang.
I sing for *Blue*.
I sit on mama's beloved chaise—

Singing a Scottish folk song.
Now reclaimed by The Culture.

Daddy-Baba was *Frank* about the birds and the bees,
preparing me—
Instead, I chose to look at the Sea—

The gurgling sound of mouthwash interceded; it
irritated me—
Journeyed me to the deep water.
The back of the throat became a simulacrum for all that
was blue.

During the holidays, I looked to the gray sky, craving for
the blue of the ocean—all and *every* one of the shades of
blue.

I was disappointed, scratch that, crestfallen to learn that
Blue did not exist.
Jacques Lacan, I would later read, professed: *The Woman
does not exist.*

Just like Blue, which *could* not be either.
I bottled up the sea, and it was crystal—
Unblemished in its Clear.
Translucent; *not* a shimmer.
Above, a similar reality existed.

I sent a letter to the arbiters of the sky—
To ask if *she* could explain why things *looked* alive, but
did not, or rather, could not, be.
I received a letter that suggested I write a Pop Song.
Bewildered as I was, the stubborn Master in me would
not relent, I wrote:

p. 100 and above:
Airmail Letter: Notes on a Blue Grid Test (detail), 2022, silkscreen print on paper, set of sixteen panels on music stands, dimensions variable. Installation view: "Water Has Perfect Memory," Hollybush Gardens, London. Photo: Alexander Christie

Lubaina Himid and Magda Stawarska, *Blue Grid Test*, 2020. Installation view:
Musée cantonal des beaux-arts, Lausanne, 2022

64 bars, 4/4, four beats in a bar, approximately three minutes, the perfect length for a pop song.
Sixteen pieces of paper with an equal division of lines representing 256 beats, with irregularly placed text in shades of blue and woven through with a narrow strip of patterned paper holding it to a song.
A song that lets you hear the blue and feel it through your body.[1]

The azure of the Mediterranean Sea or a well-worn indigo fabric.

Here is where our memories meet.

NOTE
1. Magda Stawarska, "Airmail Letter: Notes on a Blue Grid Test," *Hollybush Issue 12: Water Has a Perfect Memory* (London: Hollybush Gardens, 2022), 27–28

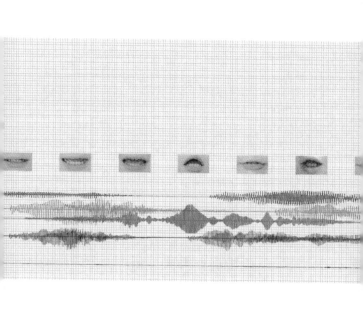

Mother Tongue II, 2009, silkscreen print, 60 × 106 cm

Route 7
Listening to Before: A Stopover

This unfinished business of my
childhood
this emerald lake
from my journey's other
side
haunts hierarchies of heavens
—Etel Adnan, "The Spring Flowers Own"

I gift people notebooks, but not just any notebooks.
They're unusual in terms of shape, texture, and size,
different than those an individual might use in day-to-day
life. The intention is to encourage one to consider the
modes, seats, receptacles of one's expression.

Sitting in the Birley studio in Preston, I notice Magda
taking notes in pencil. I query her choice of writing tool.
She says the medium of graphite leaves open the
possibility for erasure, or rather the space of its
impermanence proffers, sanctions, demands a return to
the subject. In this sense, Stawarska's art, too, is left open
for reinterpretation, animation, and forms of collaboration.

In 2018, Stawarska was invited by the curator
Christine Eyene to contribute to "Sounds Like Her:
Gender, Sound Art, and Sonic Cultures," an exhibition
held at both the New Art Exchange in Nottingham and the
York Art Gallery. Eager to expand the dialectics of sonic
practices as they interleaved with women's experiences,

Eyene invited Stawarska to present several works, including a new iteration of her project *Mother Tongue* (2006–17) and *Transliteration* (2011). *Mother Tongue* began in 2006, when Stawarska gave birth to her son, Oliver. Documenting his first cries, mapping the development of his speech until the age of three—this work presents a series of voiceprints as large silkscreens coupled with sounds that document Oliver's evolving speech patterns. The formation of an accent, switching codes across registers. Revisiting the work, Stawarska sought to examine the phonetic changes of Oliver's intonation—the impulses and shifts generated by speaking in his mother's native Polish as opposed to the northwestern English accent that has surrounded him growing up.

Transliteration grips *Mother Tongue* like a brace. Deploying the International Phonetic Alphabet, a system that standardizes the representation of sound across languages based on Latin, the artist seeks to visualize the wayward mechanisms through which speech is emitted and echoed. The work pays informal tribute to the artist Zineb Sedira's significant *Mother Tongue* (2002), exhibited at Cornerhouse in Manchester in 2004, while Stawarska was a graduate student at the Manchester School of Art. Sedira's three-channel video work of cross-generational dialogue documents the communication breakdowns across cultures that result from shifts in language, speech, and intonation.

The immaterial threads that link speech and the speaking apparatus is explored in one of Stawarska's early works, *Chameleophonia* (2005). Dressed in matte

Mother Tongue IV, 2009, silkscreen print, 60 × 106 cm

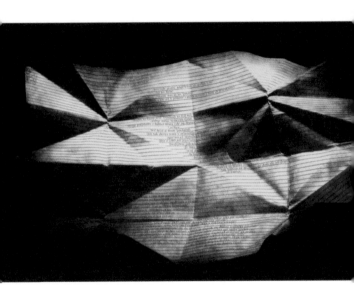

Transliteration, 2011, photointaglio, 60 × 50 cm

black, the artist stands in front of a green screen filled with an image of a wooded area, which from today's vantage point resembles a backdrop from a video teleconferencing platform. As she begins to speak, we are made aware that there are several of her. Each with subtle differentiating features, such as braided hair or a perplexed expression. As this chameleonic entity begins to speak, we find that her voice, her accent, her very sense of being, is borrowed from the voices of others. Gone is her distinct Polish lilt—rather, each character speaks in a different robust northern English accent. As the characters continue to narrate some sort of fairy tale, they begin to resemble Greek statues coming to life, dressed in all black ballet clothes. Together, these multiple women unfold her origins—a Polish identity that exists in stark contradiction to the English accents heard.

We are viewing this on her computer in the studio, sitting side by side. Magda giggles with amusement and slight embarrassment. I am enthralled. Here, between what is constructed and imagined, she explores the contradictions of how language, voice, and speech are performed. Stawarska's art reveals a preoccupation with what makes an individual both visible and invisible within migrant society in Britain.

Curtain II, 2017, silkscreen print, 121 × 81 cm

Finding Root
Every Day Is a Winding Road

Sat, 16 Sept, 15:19 (6 days ago)

Dear Omar,

Just a quick message to follow up on our various conversations. It just came to my mind as I made the final selection of slides for our show.

The wandering around the streets is something that I picked up from my dad. When my mum had to work in the hospital over weekends when I was a small girl, younger than 8, my dad used to take us for long walks, usually an urban walk, and usually not on the routes I would recognize from my daily routine, going out to play, to school, etc. We never went back on ourselves, so it was a circular walk, often involving a means of public transport, tram, or bus. We would stop in the bookshops. He did not buy us anything, but we spent time looking, also in the ice cream places or bakeries. After some time, we got lost, or at least I thought we did. Most of the time, I was really tired as the walks were long for my little legs.

I just thought I would share this memory with you.

Magda

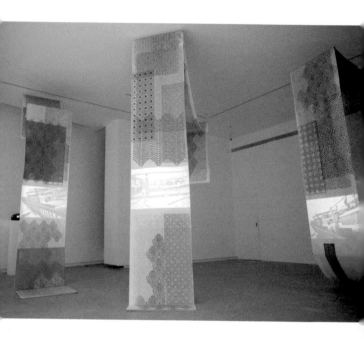

Above and pp. 116–17:
Patterns of Al-Andalus, 2023, three silkscreen prints on 75gsm Mulberry paper. Part of
Lost and Found, 2023, 240 slide projections on three carousels, duration variable.
Commissioned by Sharjah Art Foundation

Afterword: Listening
Lubaina Himid

Over the last fifteen years, Magda Stawarska has spoken to me extensively about her project to encounter and translate "the city" through a combination of recorded sound, film, and silkscreen-printed images. I have gained a greater understanding of Magda's sound work by reading Salomé Voegelin's writing. In *Listening to Noise and Silence*, Voegelin notes: "Sound invites the body into experience and reciprocally makes the object physical. Listening to sound is where objectivity and subjectivity meet in the experience of our own generative perception, we produce the objectivity from our subjective and position of listening, which in its turn is constituted by the objectivity of the object as a prior moment of hearing, subjective and particular."[1]

As a collaborator on several of Magda's projects, I have found myself navigating through her sonic city infrastructures as if attempting to constitute a world through a blindfold. It has been an extraordinary and disquieting experience. Listening to a composition of audio from Manchester, I realized that it annoyed me because it was both familiar and unknown. To understand it, I tried to translate it into the London of my youth.

Later, she asked me to navigate through her complex sound compositions of Istanbul. As I listened, I saw with startling clarity the crowded markets of Zanzibar Town, the sandy beaches of Blackpool, and the narrowest,

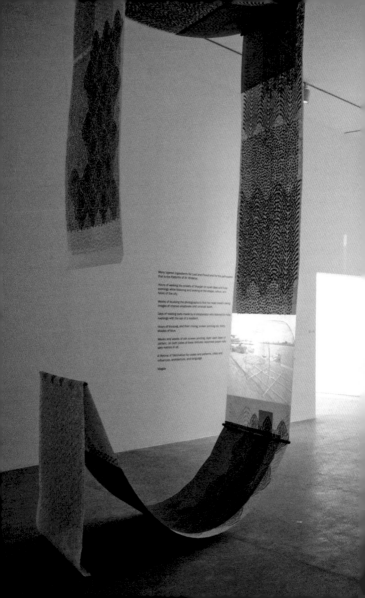

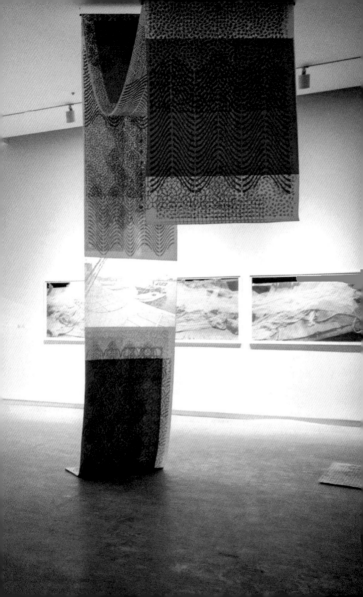

darkest passageways in Venice. The experience of hearing the huge and varied galaxy of sounds from Istanbul (a place I had never visited) enabled and encouraged a recalling and replaying of my memories, ones of being suspended in time, constantly feeling in between.

We would later return to the context of Zanzibar, where I was born, by exploring the context around a series of paintings I made in the late 1990s following a visit "home" in 1997. Our partnership resulted in a magnificent installation, first presented at the Van Abbemuseum and Villa Arson, and subsequently in our two-person exhibition "Plaited Time / Deep Water" at the Sharjah Art Foundation.

The cumulative work that is now *Zanzibar*, accompanied by Magda's sound installation, grew and flowered into new and exciting territory as she encouraged me to remember each layer of my history. She began by decoding the paintings. Magda looked at them and cared about them in a particular way. Over many weeks, she invited me to remember a visit to Zanzibar, the taarab music that I'd heard, which weaved through the European opera that I listened to on the radio as I painted. She added to the composition with archival recordings of mid-century life in Britain and combined a spoken duet between two people as they read from the guidebook that my father—from the Comoros islands— gave my English mother to reassure her that all would be well. Magda understood how the weather played its part, how patterns are codes, and how the sorrow of having to

leave a place always stays with us.

I often wonder whether Magda is attempting to provoke a reaction to that which is not seen but heard, not visualized but re-remembered. Is she undertaking what Walter Benjamin described in the fifteenth notice of the *Berlin Chronicles*?

> All these images have I preserved. None however, would give me back the Neuer See and a few hours of my childhood in the same way as would hearing once more the rhythm with which my feet, heavy with skates, regained the familiar boardwalk after a solitary sortie over the busy ice and then stumbled past the Stollwerk automats and the more splendid one where a hen lays a bon-bon filled egg, and over the threshold behind which the anthracite oven was glowing and the bench stood where the burden of iron blades on those feet, which had still to touch solid earth, could be savored for a while before you decided to undo the laces.[2]

Within the space of numerous known and unknown city structures, Magda finds herself walking, standing, observing. She is studying people—listening. In foyers, in cafés, her attention to other people's conversations and architectural surfaces—from the shine of polished stone floors to absorbent carpets in domestic interiors. Magda can hear color—the contour and texture of voices. And with it, the intonation, the pitch, and the rhythm of speech accompany her. Within the sphere of what she proclaims to be a performance of "getting lost"

Lubaina Himid and Magda Stawarska, *Zanzibar*, 1999–2023, Nine diptychs with 8-channel sound installation. Installation view: "Plaited Time / Deep Water," Sharjah Art Foundation, 2023. Photo: Danko Stjepanovic, courtesy of Sharjah Art Foundation

in cityscapes, fostering a space of "not knowing," she is, nonetheless, able to connect with the purest of feelings. Her wish or purpose is to break down barriers, to push against thresholds developed by social and political structures. To quote her: "I am hovering, not grasping, not knowing, unable to get into the visceral essence of the place."[3] Somehow within the space of her imagination, one that is bold and opaque, Magda presents inner worlds that would otherwise remain lost to history. Legacies that we cannot afford to squander.

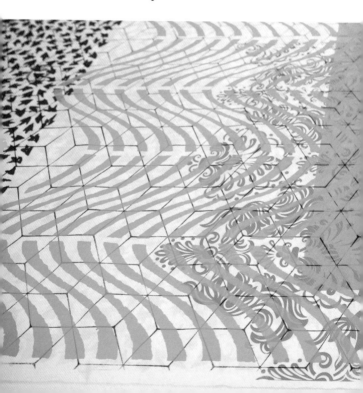

NOTES

1. Salomé Voegelin, *Listening to Noise and Silence: Towards a Philosophy of Sound Art* (New York: Continuum, 2010), 14.

2. Walter Benjamin, *The "Berlin Chronicle" Notices* (London: Pilot Editions, 2015), 51.

3. Magda Stawarska, conversation with the author, Preston, January 16, 2024.

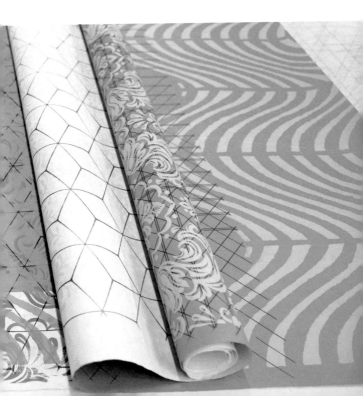

Door I, 2020, silkscreen print, 121 × 81 cm

Acknowledgments

ARTIST'S ACKNOWLEDGMENTS
I would like to thank Omar Kholeif for their enthusiasm and careful examination of my practice and for engaging in these journeys with me. Here, they take a deep dive into my work and at times, zoom and float out, hovering above to create a cinematic view of my world. I would like to thank the editorial team at Sternberg Press for including me in the series, imagine/otherwise. I am very grateful to Lubaina Himid for always believing in me, for her ongoing support—constantly encouraging me to push forward with my work. Thank you to Keiko Yamamoto Rochaix for giving me the opportunity to experiment freely in her gallery space and to ICCC and the Artlab CPS team at UCLan for their support. Thank you to Heather Ross, Alexandra Rosol, and Souraya Kreidieh for their participation.

Thanks also to Georg Weckwerth at TONSPUR Kunstverein Wien, Christine Eyene, Ekin Sana, Wolfgang Kindermann, Frank Beavan and Oliver Stawarski-Beavan for believing in me and being participants and supporters of early projects.

And thank you Aneta Krzemień for listening. —Magda Stawarska

AUTHOR'S ACKNOWLEDGMENTS I completed this manuscript at a snail's pace after sustaining nerve damage to my writing hand. Thank you to the Eye of Horus for your unwavering protection. I am grateful to everyone in this process, especially those who patiently allowed me the extra time required to arrive to completion. Always, I thank the editorial advisory committee, Caroline Schneider of Sternberg Press for allowing us to build our own mythologies, and Simon Josebury for his sensitive design. Special mention goes to Lubaina Himid for contributing an afterword to this volume, and who over the years has helped deepen my knowledge of Magda's creative brilliance. Thanks are due to the ever-sensitive editor, Max Bach, to Z. Harris for helping us break the rules the only way possible, and to Magda Stawarska for permitting me to journey with her to imagine/otherwise.
—Omar Kholeif

مؤسسة الشارقة للفنون / 29 أكتوبر - 28 يناير

زمن متضافر/ مياه عميقة

لبينا حميد ماجدة ستاوارسكا

29 OCTOBER 2023
28 JANUARY 2024
LUBAINA HIMID &
MAGDA STAWARSKA
PLAITED TIME /
DEEP WATER

Opposite:
Exhibition poster for Lubaina Himid and Magda Stawarska, "Plaited Time / Deep Water" Sharjah Art Foundation, 2023–24

Above:
Chameleophonia, 2005, digital video, 5:20 min.

Colophon

Omar Kholeif
imagine/otherwise
Vol. 2: Magda Stawarska

Editor: Max Bach
Proofreading: Z. Harris
Design: Simon Josebury,
SecMoCo, London
Printing: Maiadouro, Portugal

ISBN: 978-1-915609-29-8
ISBN hardcover:
978-1-915609-65-6

Distributed by The MIT Press,
Art Data, Les presses du réel,
and Idea Books

All images courtesy the artist,
unless otherwise stated.

Every effort has been made to
contact the rightful owners with
regard to copyrights and
permissions. We apologize for
any inadvertent errors or
omissions.

Published by

SternbergPress

Sternberg Press
71–75 Shelton Street
London WC2H 9JQ
www.sternberg-press.com

**in association with
artPost21**

**An artPost21 Production
www.artpost21.com**